IMAGES of America
POTTSVILLE FIREFIGHTING

To the Fallen

The first member of the Pottsville Fire Department killed in the line of duty was Stephen Stapleton of the Schuylkill Hydraulians. On May 4, 1832, Stapleton was struck and run over by the Schuylkill Hydraulians' apparatus while it was responding to a fire in Port Carbon. The accident occurred on what is now called the Mechanicsville hill. Stapleton was also the first firefighter from Schuylkill County killed in the line of duty. The second member of the Pottsville Fire Department killed in the line of duty was Charles Ewing of the Good Intent Fire Company. Ewing was killed on Market Street below Fifth Street on Sunday, April 14, 1872, while responding to a fire on Sanderson Street. According to company records, Ewing was thrown to the ground by the swerve of the fire engine, and one of the rear wheels ran over him, crushing his skull. Ewing was a Civil War veteran and a police officer in Pottsville. Members of the Pottsville Fire Department led his funeral cortege. The flags at the engine houses were displayed at half-mast, and the fire alarm bell was tolled as the funeral procession passed. Daniel Clauser, a member of the Phoenix Fire Company, became the third department line-of-duty death. Clauser died on February 12, 1955, after he collapsed on the engine room and stuck his head on the apparatus when returning from a fire call. Harold H. Staller, a member of the West End Fire Company, died of a massive heart attack on November 27, 1962. Staller was directing traffic on Laurel Street as a fire policeman. The final department line-of-duty fatality occurred on December 15, 1978. Ralph Downing, a member of the Humane Fire Company, perished after being struck by a car on November 18, 1978. Downing was directing traffic on Route 61 at the Mount Carbon intersection.

IMAGES
of America

POTTSVILLE
FIREFIGHTING

Michael R. Glore and Michael J. Kitsock

ARCADIA

Copyright © 2004 by Michael R. Glore and Michael J. Kitsock
ISBN 0-7385-3616-4

First published 2004

Published by Arcadia Publishing,
Charleston SC, Chicago IL, Portsmouth NH, San Francisco CA

Printed in Great Britain

Library of Congress Catalog Card Number: 2004104021

For all general information, contact Arcadia Publishing:
Telephone 843-853-2070
Fax 843-853-0044
E-mail sales@arcadiapublishing.com
For customer service and orders:
Toll-free 1-888-313-2665

Visit us on the Internet at www.arcadiapublishing.com

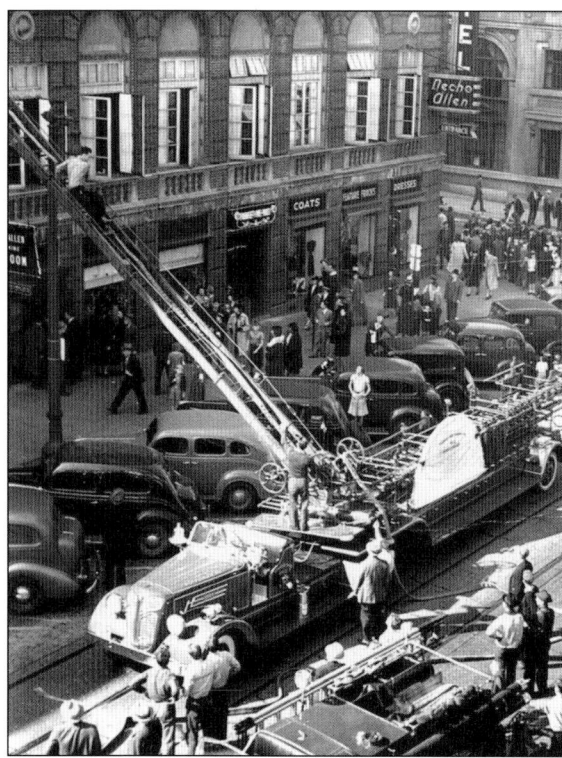

The 75-foot wooden aerial ladder, or "stick," on Phoenix's 1939 Hahn is up at this fire, at the Necho Allen Hotel, at Centre and Mahantongo Streets. Box 36 sounded at 11:54 a.m. on October 20, 1939, after grease ignited in an air duct, causing $1,200 worth of damage. Good Intent Company's 1937 Ahrens-Fox 500-gallon-per-minute pumper can be seen in the foreground.

Contents

Acknowledgments 6

Introduction 7

1. The Early Years: A Fire Department Is Born 9

2. The Great Fire of 1914 21

3. The Golden Era: 1925–1955 31

4. Coming of Age: 1956–1969 49

5. Trial by Fire: 1970–1979 83

6. The Modern Era: 1980–Present 107

Acknowledgments

If not otherwise noted, the photographs contained herein are from the collection of the Good Intent Fire Company No. 1. In addition, the authors would like to thank Leo Ward and the Historical Society of Schuylkill County for the use of the photographs in its collection and for obtaining remarkable reprints of Pottsville's Great Fire of 1914 from a nearly 100-year-old scrapbook. Both the Humane Fire Company No. 1 and the Phoenix Fire Engine Company No. 2 contributed photographs from their collections as well. We thank our brother and sister firefighters for their generosity. Photographs and materials from the Schuylkill Historical Fire Society also greatly contributed to this work.

A work such as this would not be complete without expressing our thanks to the late Bill Cerullo of the American Hose Company No. 2 and to Joe Neary of the Good Intent Fire Company No. 1. Their pioneering work in chronicling the history of the Pottsville Fire Department, including apparatus, fire records, and other significant events, proved invaluable in assembling this book. In addition, we would like to thank George Glore of the West End Hose Company No. 7 for his critical eye in selecting and sorting the photographs and for identifying locations and firefighters.

As this book was being assembled, one could almost smell the burned wood and wet plaster of fires fought many years ago. The book is not only a tribute to the smoke-eaters of times past but also an acknowledgment of the dedicated men and women who will carry the Pottsville Fire Department into the future. We hope that you will find this book as exciting and enriching to read as it was for us to write.

—Michael R. Glore and Michael J. Kitsock

INTRODUCTION

The year 2004 marks the 175th anniversary of firefighting in the city of Pottsville. In 1829, the Humane Hose Company No. 1 and the Schuylkill Hydraulians Engine Company organized in the rapidly developing town of Pottsville, a mining center of Pennsylvania's anthracite region. The discovery of anthracite by Necho Allen in 1790 led to an influx of thousands of people to the Pottsville area. With Pottsville's swift industrialization and growth, fire protection was urgency needed for this young, prosperous community where coal was becoming king. The "coal rush" era had commenced.

The rapid expansion of Pottsville into a city during the early anthracite era created additional needs for fire protection. With the Industrial Revolution in full sway, Pottsville's mills, mines, and railroads thrived. New fire companies boasting such proud names as the Good Intent, the Rough and Ready, and the Good Will were being chartered. Junior fire companies were also forming, including the Rangers and the Young America. On a tragic note, the dangerous aspect of local firefighting became readily apparent when Stephen Stapleton, a member of the Schuylkill Hydraulians, was struck by the apparatus and killed in 1832. Stapleton was the first line-of-duty death in Schuylkill County. The thorny issues of slavery and states' rights were still unsettled, however, bringing new challenges to the young fire department. In a patriotic response to Pres. Abraham Lincoln's call to arms, two Pottsville fire companies disbanded, committing their active membership to the valiant effort to save the Union. Two other Pottsville fire companies also committed most of their membership. These firefighters became soldiers of the legendary First Defenders in the Civil War.

The steam era commenced in the Pottsville Fire Department in 1866 with the arrival of Good Intent's Amoskeag third-class steam engine, a horse-drawn unit. Also in 1866, the Humane Hose Company purchased a hand-drawn Clapp & Jones steamer. After acquiring the steamer, the Humane changed its name to reflect proudly its latest acquisition, becoming the Humane Hose and Steam Fire Company No. 1. For the next 60 years, steam powered most pumps of the Pottsville Fire Department. With the continued industrial and residential growth of Pottsville, additional steam engine purchases occurred from Clapp & Jones, Manchester, Silsby, and American LaFrance. The last steam fire engine obtained for the Pottsville Fire Department was on October 1, 1907. The West End Hose Company purchased an Amoskeag steam fire engine at a cost of $9,000. Horses were included in the price. These later steam fire engines were eventually motorized. The 1920s witnessed the demise of a colorful era of the Pottsville Fire Department. The horse-drawn apparatus era ended, followed closely by the termination of steam-powered fire pumps.

One fascinating 19th-century invention still serves the Pottsville Fire Department. In January 1890, the Pottsville City Council purchased a new fire alarm system from the Gamewell Company of New York City. The continuous growth of Pottsville during this era necessitated a faster means to transmit fire alarms. A new Gamewell telegraph fire alarm system was installed in city hall, with street boxes conveniently placed throughout the city. A cog-driven transmitter allowed for boxes to be sent from city hall. A striker mechanism on the roof of city hall struck the box number on the fire bell. The Gamewell system incorporated the latest 19th-century technology of telegraphy. The Pottsville Fire Department, unlike any other, has incorporated its 19th-century Gamewell fire alarm equipment into the 21st century. Visit any

Pottsville fire station today and marvel at its original house bells, tape registers, and indicators, still on active duty.

Pottsville's Great Fire of 1914 seriously tested the department's mettle while ravaging an entire block in the business district. An entire chapter of this book explores the devastation of this catastrophic event, as well as the fire equipment used to fight the conflagration. The 20th century brought the end of the fire horses and steam power, as well as new challenges of motorization, dieselization, and increasingly stricter training standards. While the fortunes of the city of Pottsville waned during the latter 20th century, the Pottsville Fire Department thrived, maintaining eight fully equipped stations during a nationwide trend of downsizing and consolidation. During its 19th-century origins and throughout the 20th century, the Pottsville Fire Department proudly marched in uniform and displayed its equipment in numerous local, state, and out-of-state events.

What fire department in the United States the size of Pottsville boasts a more diverse roster of apparatus? Throughout *Pottsville Firefighting*, the photographs reveal firsthand the vital role of many fire apparatus manufacturers. The big three of fire apparatus builders are well represented: American LaFrance, Seagrave, and Ahrens-Fox. Smaller manufacturers, such as Robinson, Oren, Hahn, Maxim, Buffalo, and Pierce, and commercial chassis builders, such as White, Ford, and GMC, are all depicted in action photographs.

Pottsville authors Michael R. Glore and Michael J. Kitsock have combined their love of the volunteer fire service and their years of firefighting experience into narrating this fascinating account. Drawing upon a wealth of Good Intent Fire Company photographs and other fire company archives, *Pottsville Firefighting* explores the development, the equipment, the firefighters, and the successes and failures of one of the nation's largest all-volunteer fire departments. In the opinion of the authors, no city today in the United States the size of Pottsville boasts a prouder, better-trained, or finer-equipped fire department.

One

THE EARLY YEARS

A FIRE DEPARTMENT IS BORN

In 1829, prominent citizens of Pottsville conducted meetings in the school building on Centre Street to organize fire protection for their rapidly developing community. As a result of these meetings, two fire companies were organized: the Schuylkill Hydraulians and the Pottsville Fire Company No. 1. The Schuylkill Hydraulians were predecessors to the Phoenix Fire Company, and the Pottsville Fire Company was later renamed the Humane Hose Company No. 1. The earliest firefighting equipment included a four-wheeled, double-decked hand pumper with copper-riveted leather fire hose and two small hand pumpers, "Squirt" and "Ranger." Additionally, each fire company member received a fire bucket for firefighting use throughout the borough.

The Good Intent Fire Company No. 1 organized on October 5, 1846. With the rapid expansion of Pottsville, many citizens believed firefighting efforts were inadequate. On June 30, 1848, the Rough and Ready Fire Company, predecessor to the American Hose Company, was formed. The first company response was to the Great Fire of 1848, which destroyed a block of homes and businesses on Callowhill and Railroad Streets. At the outbreak of the Civil War, many members of the Pottsville Fire Department enlisted with Pottsville's famous First Defenders. The Schuylkill Hydraulians and the Rough and Ready sent all of their active members, leaving fire protection to Good Samaritan citizens. Most members of the Humane and Good Intent also enlisted. On April 14, 1872, Charles Ewing of the Good Intent Fire Company became the second Pottsville firefighter killed in the line of duty. Ewing was run over by the fire engine that was responding to a fire on Sanderson Street.

Predecessors of the junior firefighters of today were the boy companies. Three of Pottsville's four fire companies sponsored boy companies during this era. The earliest of these companies were the Rangers. The Rangers were affiliated with the Rough and Ready Fire Company, later renamed the American Hose Company. The Ranger boys used the old hand pumper "Ranger." Numerous incendiary fires in the 1840s aroused the suspicion of citizens, and the Rangers soon disbanded. The Schuylkill Hydraulians sponsored the Western boys. This boy company provided fire service during the Civil War and paraded with the Drollies (Schuylkill Hydraulians). Information is scant, however, about the Western boys. An active group of young men organized the Young America Fire Company in 1858, affiliating themselves with the Good Intent Fire Company. Soon after the Civil War ended, Pottsville's boy fire companies were banned.

With the continued growth of the borough of Pottsville, three additional fire companies organized: the Atkins Fire Company on September 29, 1873; the Good Will Fire Company on March 28, 1882; and the West End Hose Company No. 7 on September 7, 1886. On April 17, 1894, the Atkins Fire Company disbanded. The Yorkville Hose & Fire Company No. 1 organized on October 27, 1891. When the borough of Yorkville was annexed into the city of Pottsville in 1907, Yorkville became the seventh fire company in the city of Pottsville, replacing the Atkins Fire Company. In January 1890, the Pottsville Borough Council purchased a new Gamewell fire alarm system. This telegraph fire alarm system, with its street boxes, house bells, indicators, and tape registers, still serves the city today. In 1873, Pottsville selected its first fire chief, D. A. Smith.

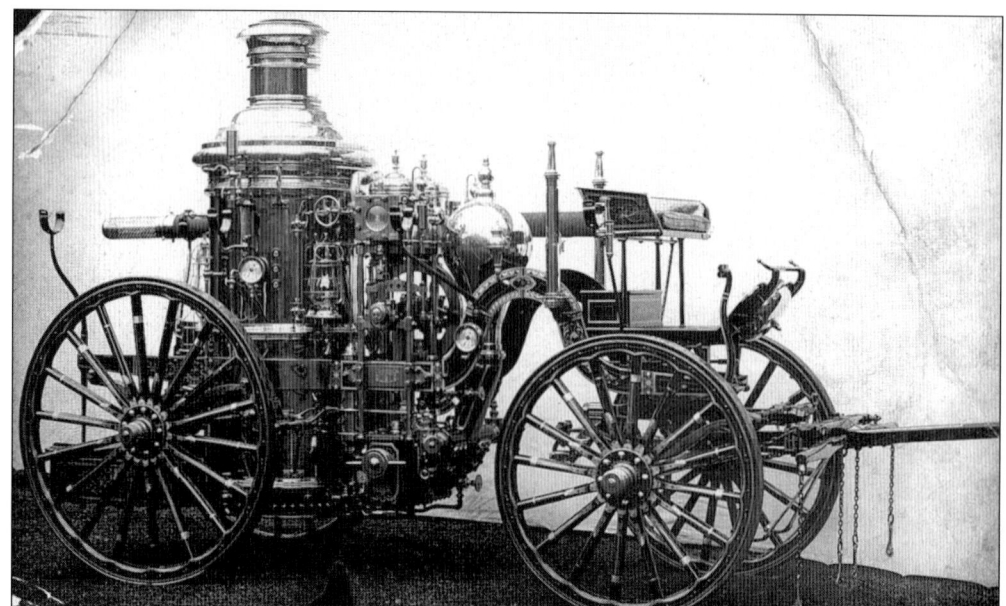

Shown on a sales card produced by the American Fire Engine Company, Humane's 1871 Silsby rotary steamer is handsomely posed. This was Humane's first horse-drawn piece of equipment. It served the company until 1921, when a Seagrave triple combination pumper was purchased. (Humane Fire Company No. 1.)

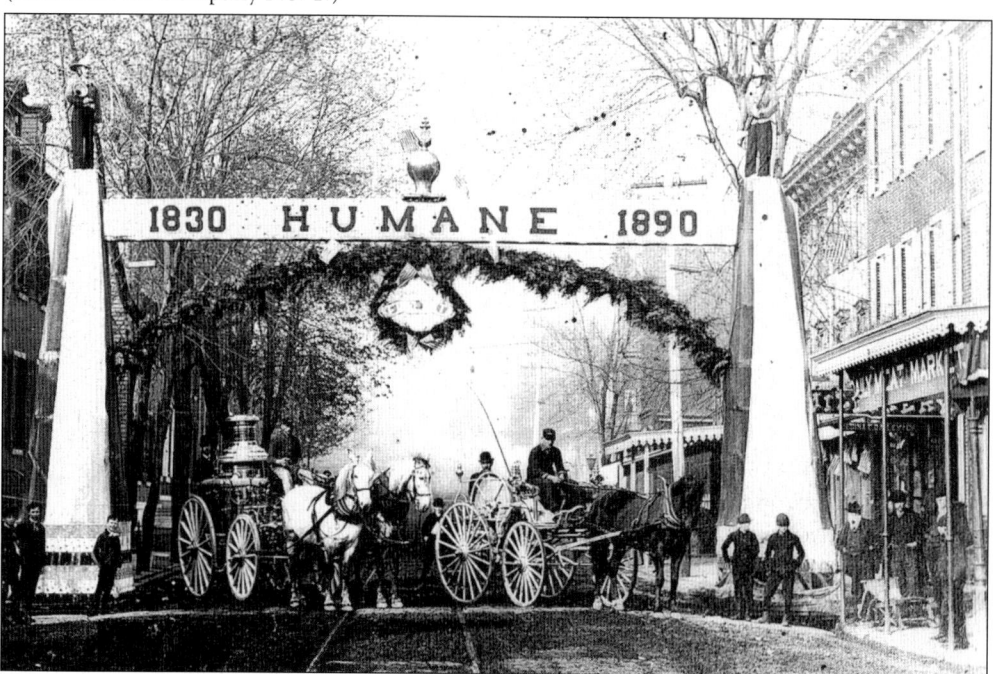

An ornate arch was erected in the 300 block of West Market Street to commemorate the 60th anniversary of the Humane Fire Company. Note the firefighter statues atop the pillars and the steamer lantern in the center. The company's 1871 Silsby steamer and hose carriage are pictured. The celebration may also commemorate the company's move to new quarters at Third and Laurel Streets. (Historical Society of Schuylkill County.)

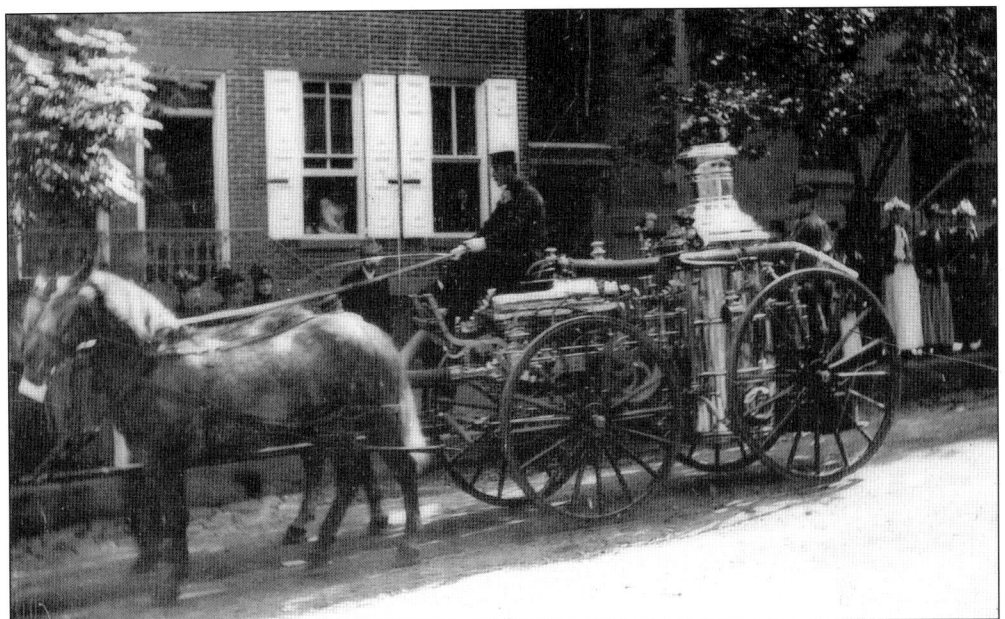

Pictured on Mahantongo Street in 1890 is the American Hose Company's horse-drawn 1875 Clapp & Jones steam engine. The steamer was purchased at a cost of $3,800 and was nicknamed "the Little Captain." (Historical Society of Schuylkill County.)

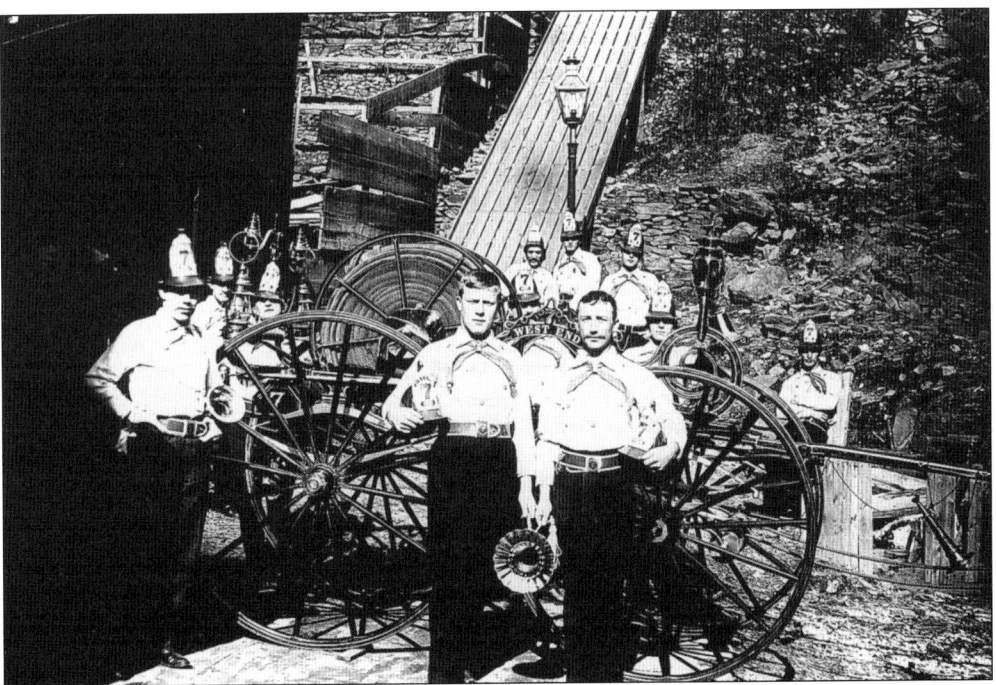

Pictured in 1888 are the members of the West End Hose Company No. 7 posing with the company's D. G. Matthews crane neck hose carriage. The hose carriage was purchased in 1887 at a cost of $525 and was hand drawn. The photograph was taken at the company's original quarters, on North 10th Street behind Anton Reinhart's Hotel. (Historical Society of Schuylkill County.)

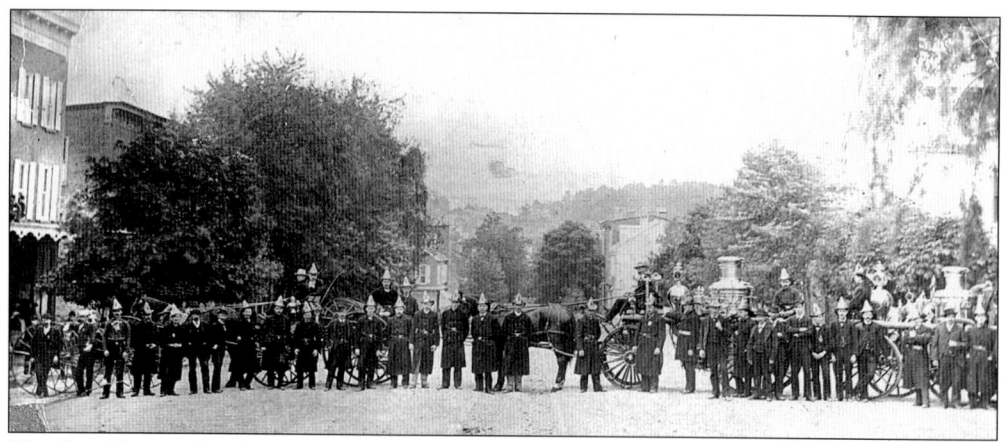

The Good Intent Fire Company poses with horse-drawn equipment in Garfield Square in 1883, a time before the Soldiers and Sailors Monument was built. The company equipment, pictured from left to right, includes the new hose carriage, purchased from W. W. Wunder of Reading; the new Amoskeag third-class steam fire engine, manufactured by the Manchester Locomotive Works in Manchester, New Hampshire; and the 1866 Amoskeag third-class steam engine No. 199, which the new steamer replaced. This is the steamer currently owned and exquisitely maintained by the Mountaineer Hose Company of Minersville.

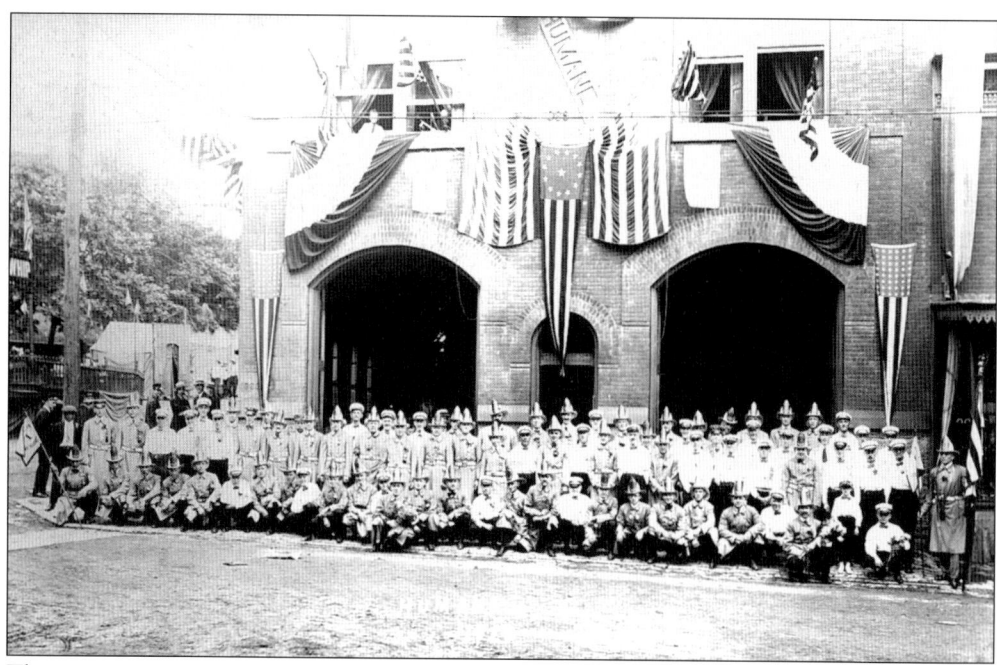

The Humane Fire Company is pictured in front of its quarters on Third Street at Laurel in 1920. Bunting decorates the firehouse, and what appear to be attractions on Laurel Street (left) indicate that a celebration of some sort is under way. The company's now famous block parties began in 1950. (Humane Fire Company No. 1.)

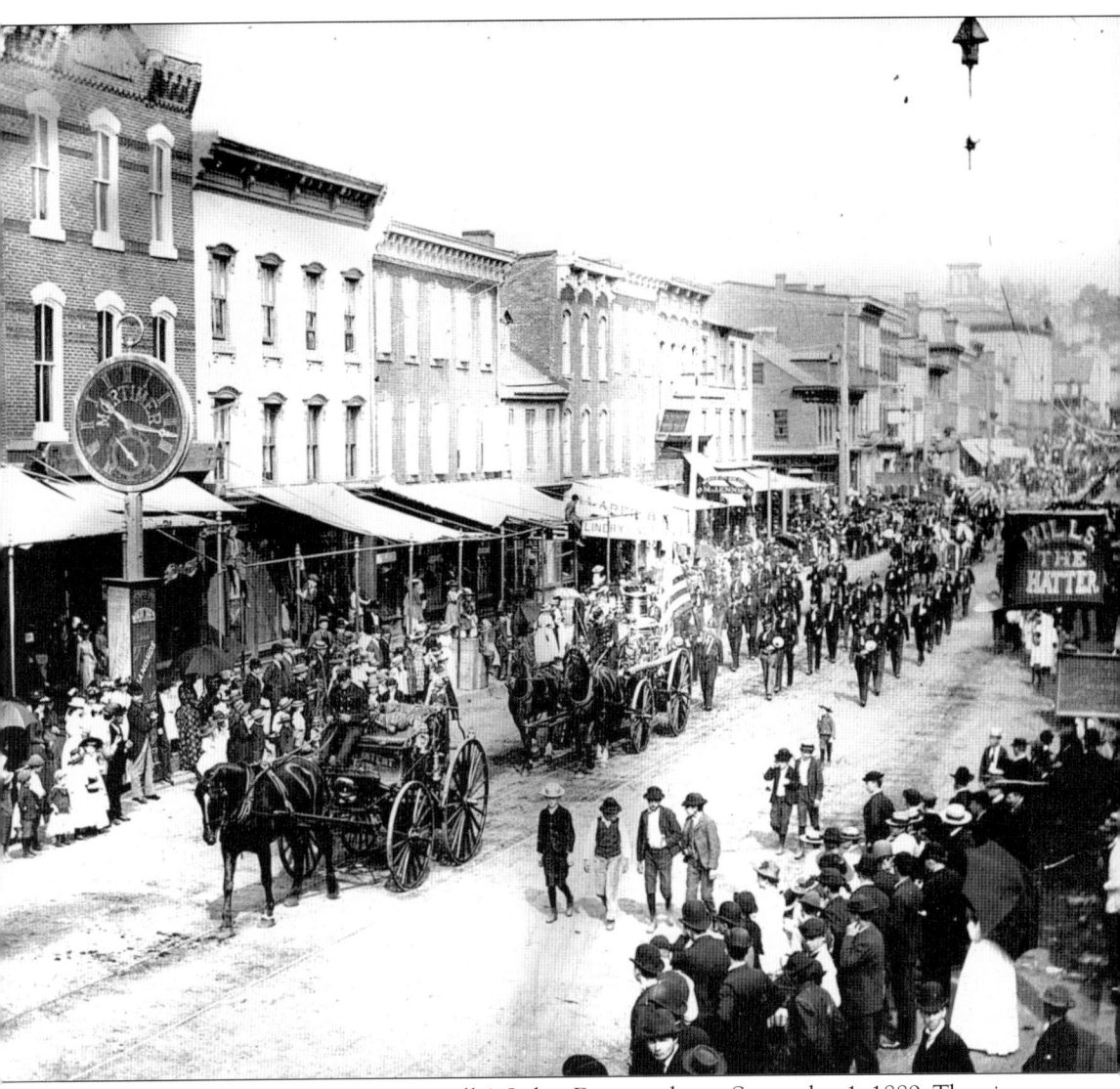

The Good Intent participates in Pottsville's Labor Day parade, on September 1, 1889. The view is of Centre Street looking north from Norwegian. Pictured are the company's 1883 spider hose carriage and 1883 Amoskeag steamer. Note the clock on the left in front of Mortimer Jewelers. Following the Good Intent equipment appears to be the Phoenix Fire Company No. 2, with its horse-drawn ladder truck.

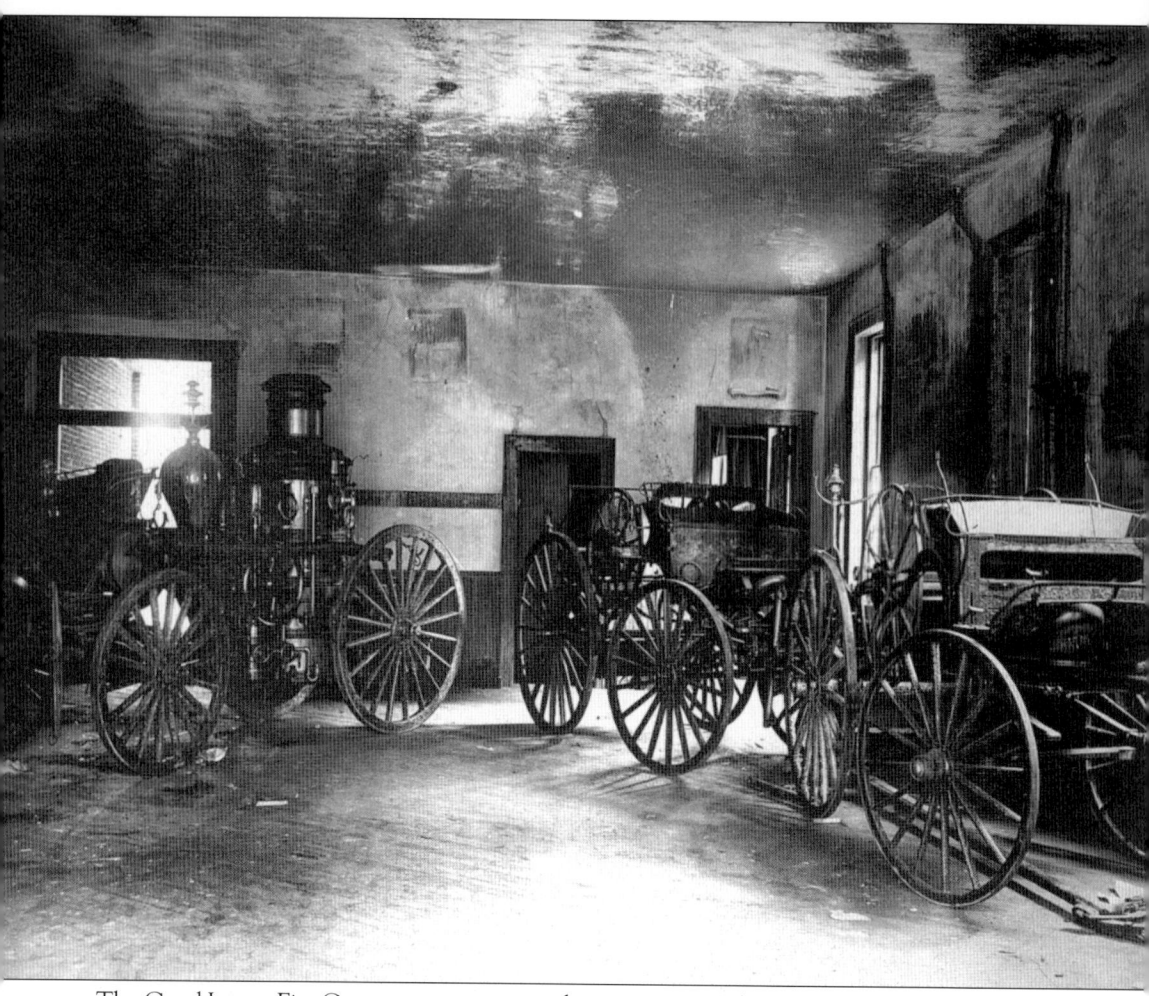

The Good Intent Fire Company apparatus and engine room is depicted after an arson fire heavily damaged the equipment. Charring can be seen on the Amoskeag steamer as well as on the two hose carriages. The fire occurred on April 19, 1904. A reward of $100 was offered "for the apprehension of the culprit." Note the Gamewell fire alarm indicator on the wall on the right. The photograph was taken at a time before the pressed-tin walls and ceiling were installed.

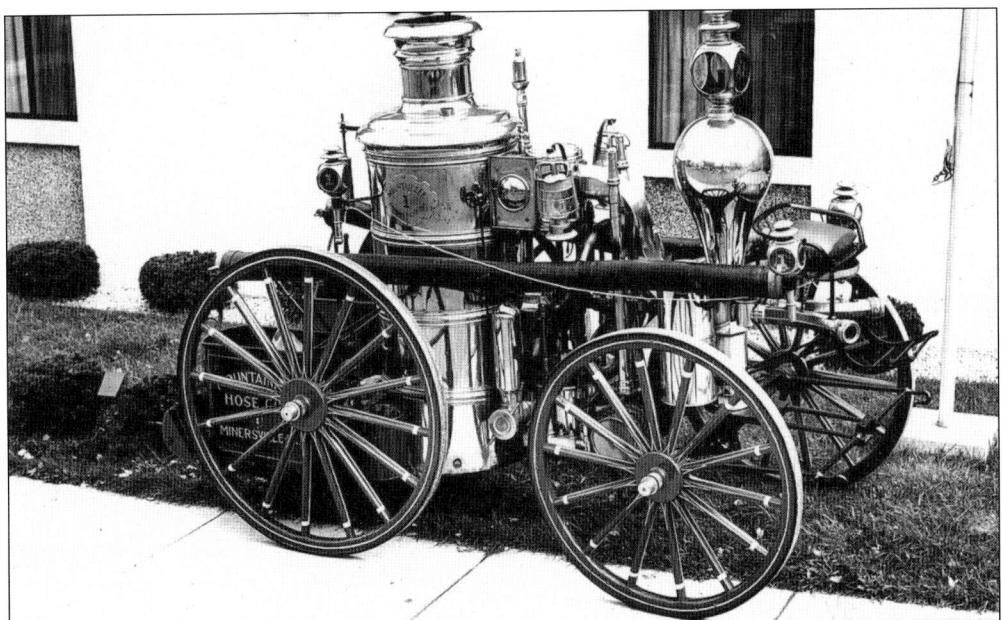

Posed next to the Mountaineer Fire Company in Minersville is the 1866 Amoskeag third-class steamer No. 199, originally owned by the Good Intent Fire Company No. 1. The steamer miraculously survived the scrap heap through two world wars. The steamer was sold to the Mounties—as the Mountaineer firefighters were known—in 1887. (Historical Society of Schuylkill County.)

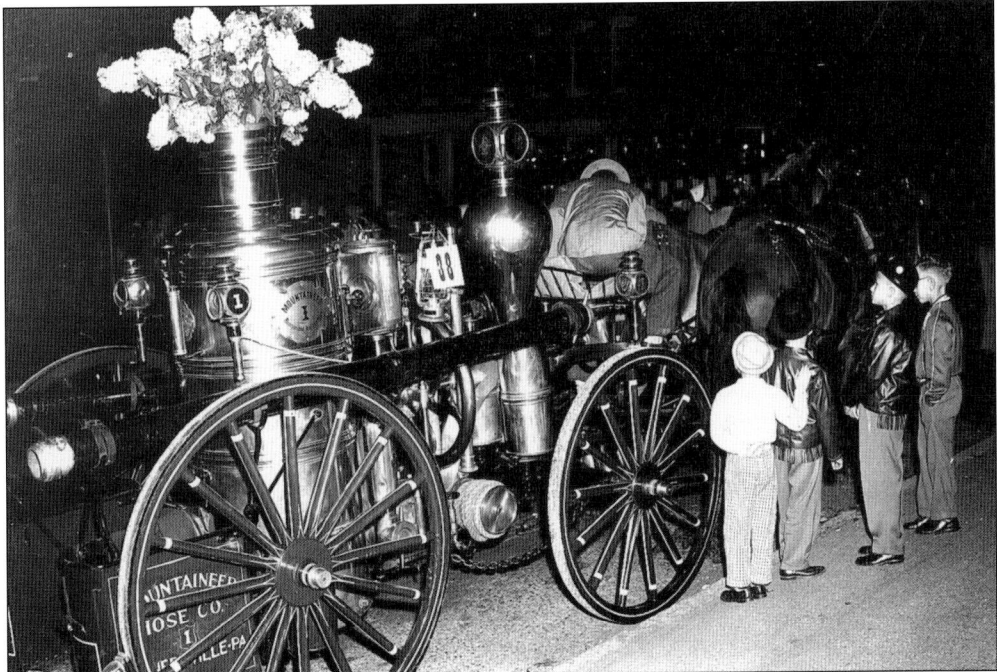

The Mounties have the 1866 Amoskeag steamer in parade form, complete with a floral bouquet placed in the boiler smokestack. The steamer is evidently registered No. 38 in this parade, as indicated by the placard on the side. Several young boys closely examine the horse hitch.

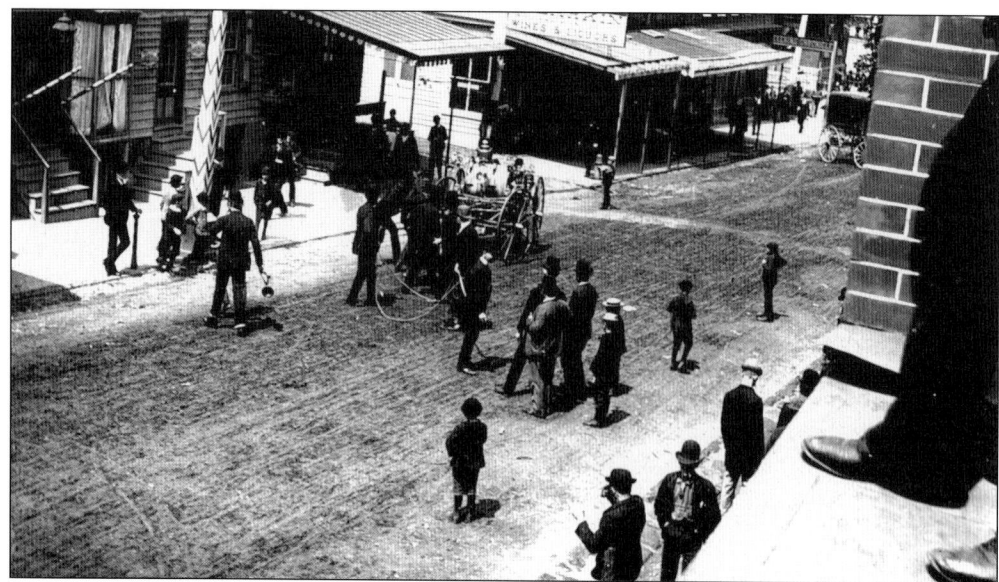

The photograph is captioned "fire scene of East Norwegian St.," but it may well have been some sort of drill or demonstration. The spectators seem more interested in the activities of the firefighters than of any active fire nearby. Note the foreman to the left with the speaking trumpet dangling from his hand. The closest that the fire alarm record comes, judging by the period and the time of day, is a slight fire at the offices of the *Evening Chronicle* on Friday, March 22, 1878. (Historical Society of Schuylkill County.)

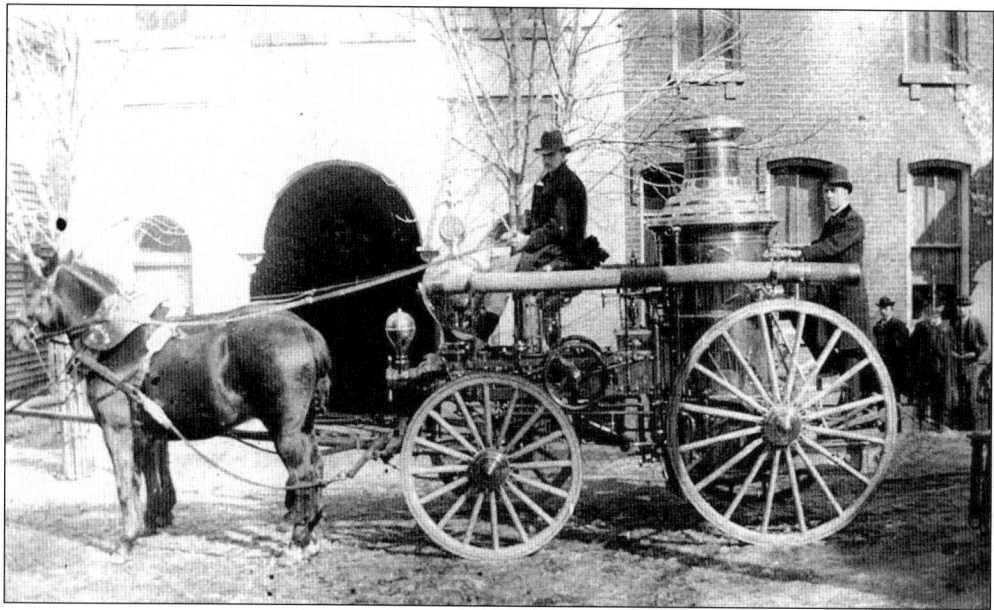

Humane's 1871 Silsby 750-gallon-per-minute steam engine is pictured in front of the company's quarters, which had been at 14 North Third Street. The company moved to its present location at Third and Laurel Streets in 1889. The original building on Third Street still stands and once served as Pottsville City Hall, as well as the headquarters of the Historical Society of Schuylkill County. It is the present location of the Joint Veterans Council. (Historical Society of Schuylkill County.)

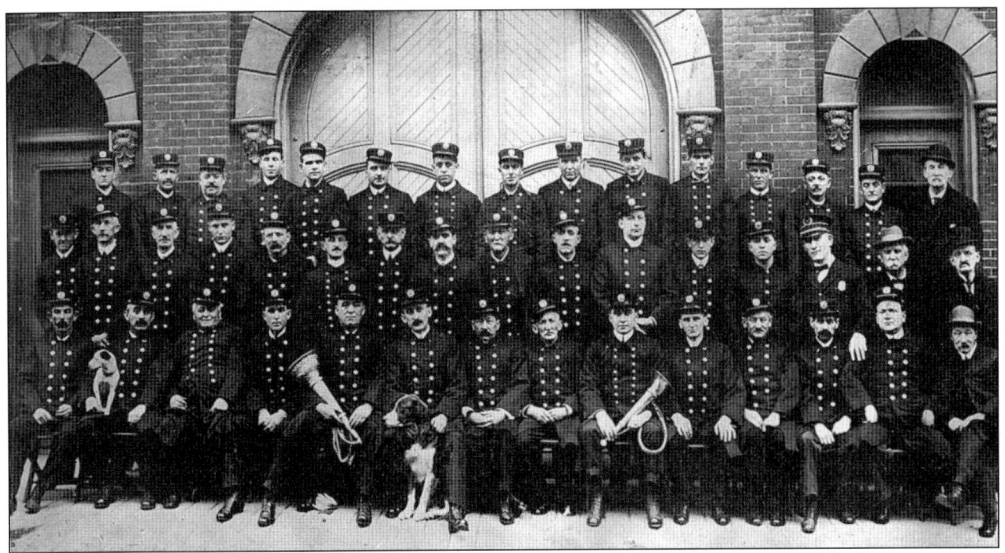

The Good Intent Fire Company No. 1 poses in front of the firehouse *c.* 1900. The firehouse is still located at 7 North Second Street. The arched apparatus door and man door on the right were removed and replaced with the squared-off apparatus entrance present today.

The Phoenix Fire Company No. 2 poses in front of the firehouse *c.* 1900. The Phoenix moved to this location, on East Norwegian Street, in 1884. Its original quarters was on North Centre Street near the Centre Street School, the current home of the Historical Society of Schuylkill County.

This c. 1900 photograph of the American Hose Company No. 2 was taken in front of the firehouse. The American Hose Company No. 2 purchased the site for its firehouse at Fourth and West Norwegian Street on March 25, 1869. The building's facade was remodeled in the 1950s and features a dramatically different appearance. The company also constructed its social quarters on an adjacent lot in 1960.

The Good Will Fire Company No. 4 poses in front of the firehouse c. 1900. The Good Will's original firehouse still stands on Prospect Street, just off Walnut. This photograph, however, was taken in front of the company's current firehouse, at Coal and Nichols Streets. The Good Will moved to this location on November 14, 1899.

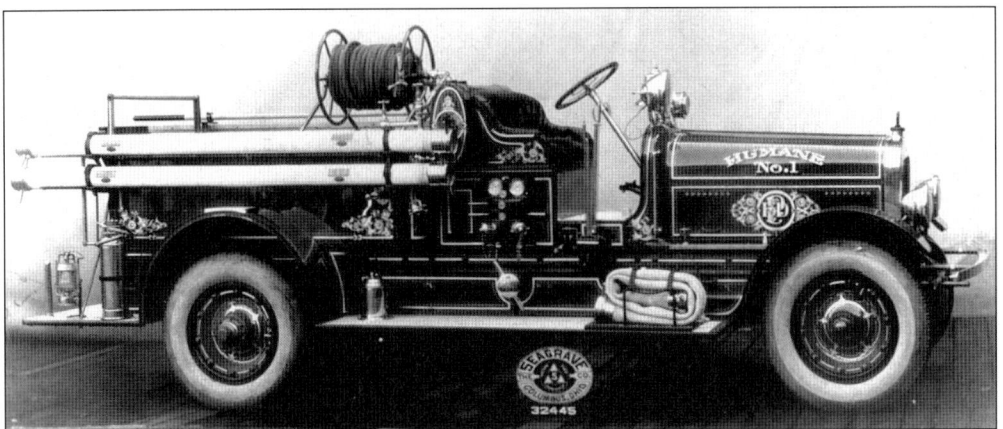

Taken on the railroad siding next to the Seagrave Fire Apparatus plant in Columbus, Ohio, this photograph shows the Humane Fire Company's 1921 triple combination pumper. The engine was purchased at a cost of $13,000. Note the ornate "PFD" on the hood just above the front fender. This engine was donated by the Humane to the Mill Creek Fire Company in 1953. (Humane Fire Company No. 1.)

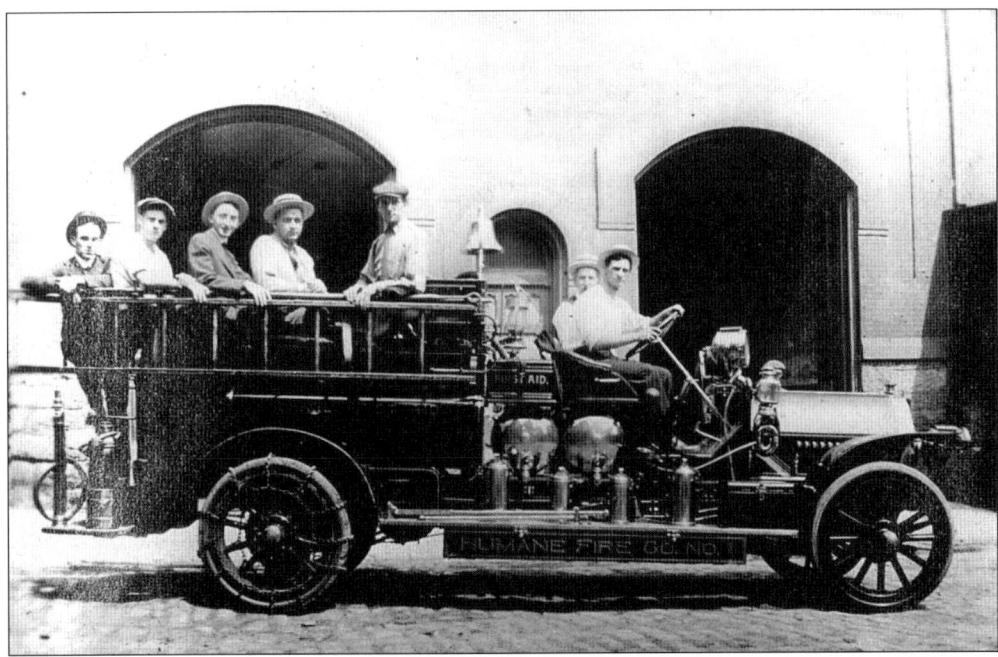

Photographed in front of quarters is the Humane Fire Company's first motorized fire apparatus. The rig is a 1911 Knox chemical and hose truck. Note the chemical tanks located under the front seat. This unit was sold in 1929 to the Humane Fire Company of Mahanoy City. "Humane First Aid" is displayed on the side of the rig. Perhaps this was a precursor to the modern quick response system (QRS) designation in the emergency medical service (EMS) field. (Humane Fire Company No. 1.)

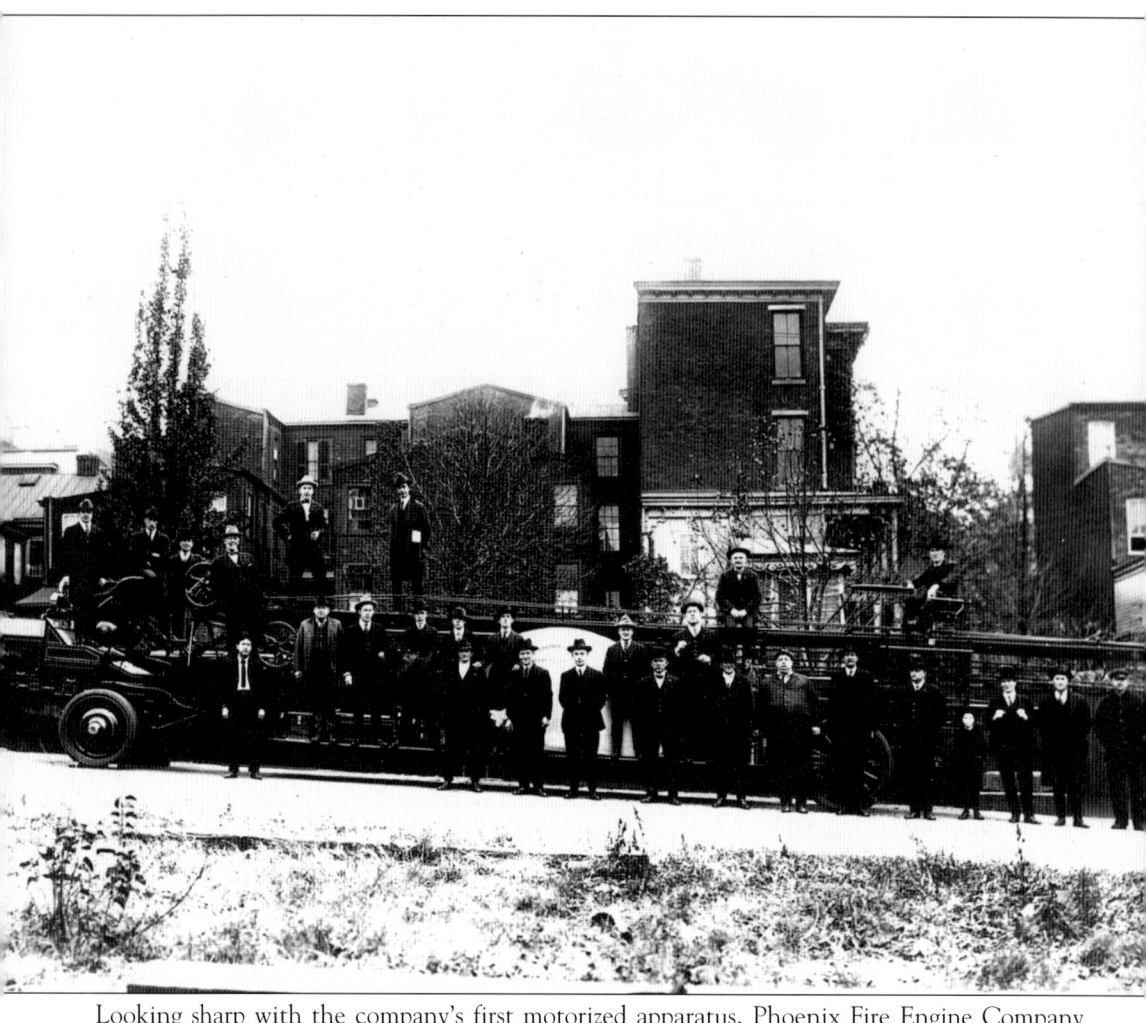

Looking sharp with the company's first motorized apparatus, Phoenix Fire Engine Company No. 2 members pose with their 1919 American LaFrance 75-foot wooden aerial ladder truck. Even with a tillerman, this rig had to be difficult to negotiate on the streets of Pottsville. (Phoenix Fire Engine Company No. 2.)

Two

THE GREAT FIRE OF 1914

The most serious fire to strike the city of Pottsville occurred on December 17, 1914. An entire city block in the downtown business district was destroyed by the inferno. The fire began about 3:00 a.m. in the Woolworth store on west side of Centre Street between Norwegian and Mahantongo Streets. Officer Moyer of the Pottsville Police Department and Ed Winger, a brakeman for the Reading Company, discovered the fire. Moyer turned in the alarm from Box 18 at 3:18 a.m. Returning to the scene, Moyer found the fire had already advanced to the third floor of Woolworth's and was rapidly spreading. The Good Intent and the American Hose were the first companies to arrive at the scene. Realizing the ferocity of the fire, Fire Chief James Lynaugh transmitted a general alarm. The zero-degree weather and high winds made the battle even more difficult.

The general alarm for help brought quick responses from several communities. Palo Alto was the first out-of-town fire company to arrive, followed quickly by companies from Minersville, Schuylkill Haven, and Saint Clair. The Alert Fire Company of Saint Clair sent its steamer, chemical wagon, and hose carts. The fire quickly spread from the Woolworth building, in the center of the block, in all directions. Most of the downtown businesses were stocked with holiday gifts, thus adding fuel to the fire. The fire engulfed the Cowen Building, the Mortimer Hat Store, the Miehle department store, and the Pennsylvania National Bank. The fire raced up Mahantongo Street, destroying the Academy of Music and the Union Hall. Firefighters placed more than 25 hoses in service in a vain effort to save the block. By 8:00 a.m., however, only the charred shell of the entire block remained.

At the height of the fire, the entire downtown business district was threatened. High winds blew burning debris as far east as Palo Alto, and flames almost jumped Mahantongo and Norwegian Streets. A collapse of Union Hall was also feared, thus spreading the fire to the *Republican* newspaper building and to the Hotel Allen. A serious drop in water pressure during the fire hindered firefighters' efforts. As Lynaugh was directing firefighting operations, Police Chief Cecil Wilhelm ordered all Pottsville police to the scene. Pennsylvania state police from the Nichols Street barracks also responded to assist in crowd control. Only valiant efforts by firefighters prevented the fire from spreading across West Norwegian Streets at its narrowest part. Some buildings on the north side of the street did sustain considerable damage.

Losses from the fire totaled approximately $1 million, a considerable sum of money at that time. Only two-thirds of the fire loss was covered by insurance. Although new buildings were soon erected on the devastated block, some businesses, including the Academy of Music, were never rebuilt. The only building spared by the inferno was the Union Bank building at Centre and Mahantongo Streets, a business still serving the community today. Facades of three buildings, the Miller and Miller Building, the Lecher Building, and the Cohen Building also remain today.

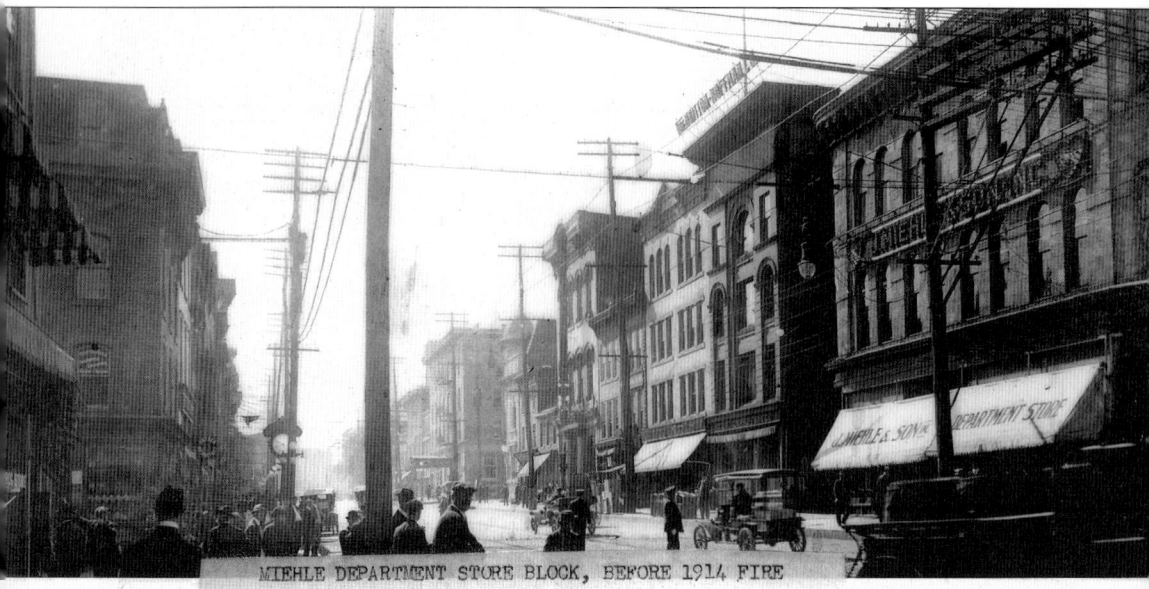
MIEHLE DEPARTMENT STORE BLOCK, BEFORE 1914 FIRE

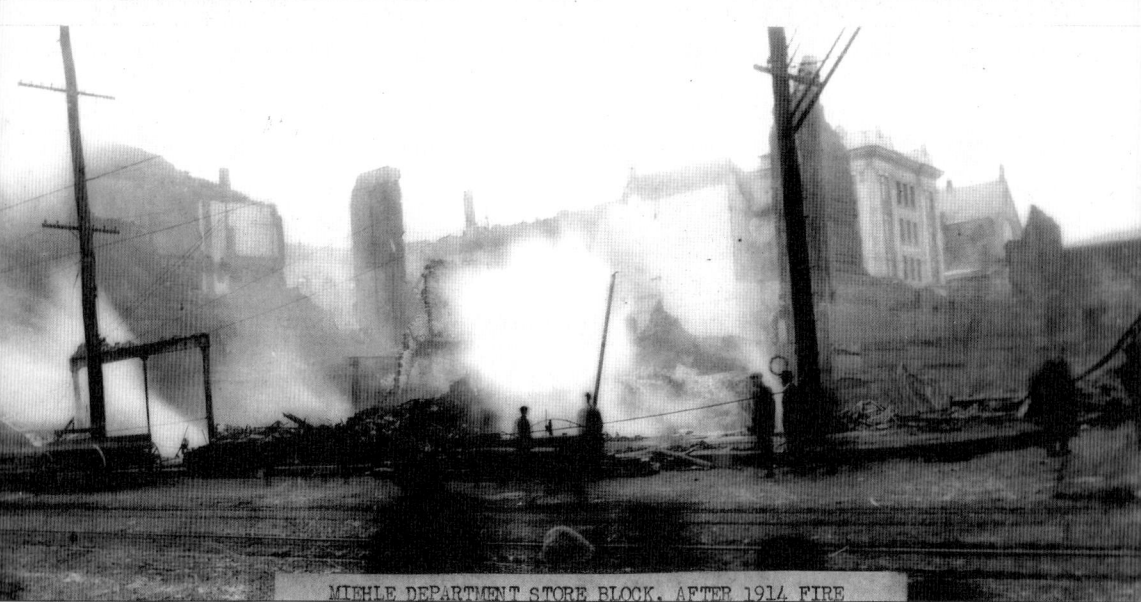
MIEHLE DEPARTMENT STORE BLOCK, AFTER 1914 FIRE

Here is a unique historical perspective of the unit block of the west side of Centre Street before and after the Great Fire of 1914. The J. Miehle department store was located on the southwest corner of Centre and Norwegian Streets. The Woolworth store, where the fire is suspected to have begun, is in the middle of the block. The size and construction of these building would present modern firefighting forces with a distinct challenge. One can imagine the challenges faced in 1914. (Historical Society of Schuylkill County.)

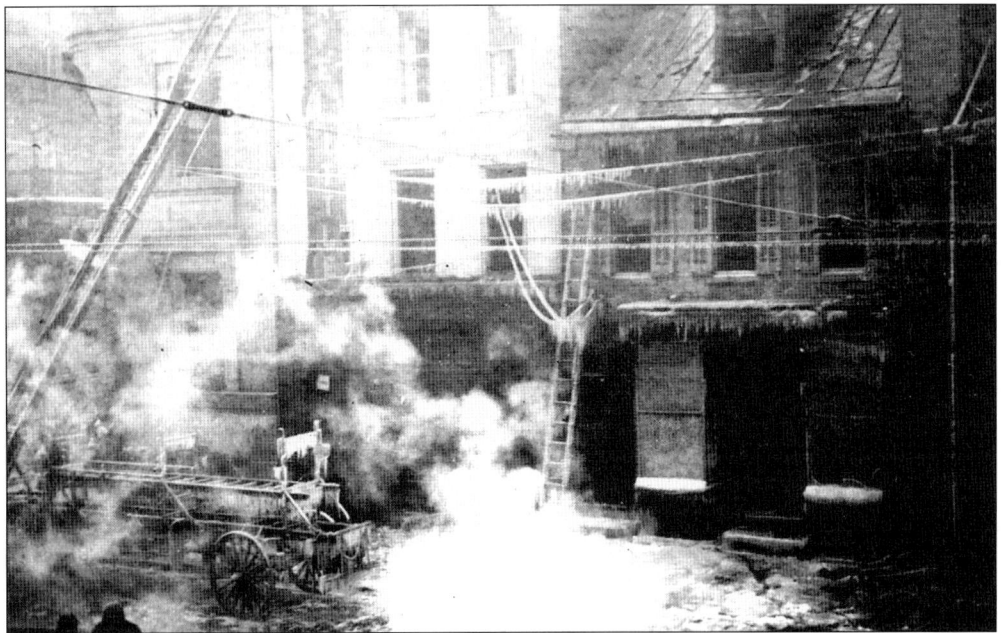

Steam rises in this scene, with the wooden aerial ladder of Phoenix Fire Company's 1899 Hayes hook and ladder to the left. This rig was drawn by three horses. Note the ice buildup on the rig, the street, and the utility lines. Damage approached $1 million (1914 dollars). (Schuylkill County Historical Society.)

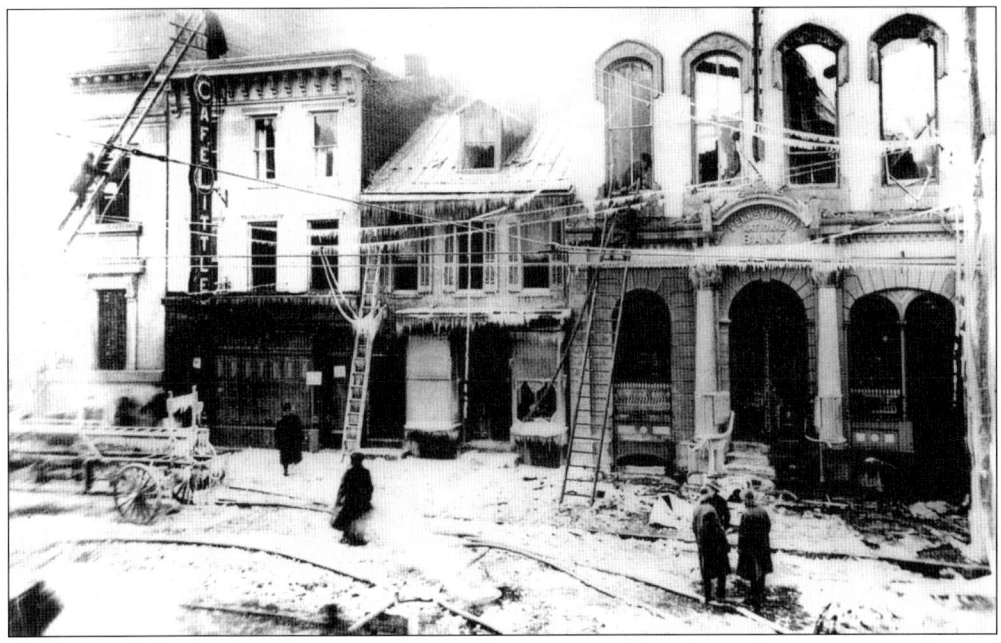

Firefighters overhaul the interior of the Pennsylvania National Bank as others operate on the roof of the Café Little (left). The Union Bank (far left) is the only building in the entire block bounded by Centre, South Second, Norwegian, and Mahantongo Streets to have survived the fire. It still stands today. Note the hose lines frozen in the street. (Schuylkill County Historical Society.)

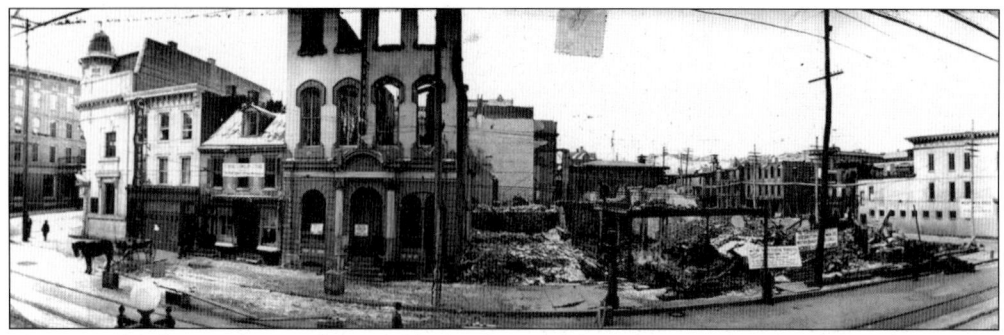

Shown is the devastation in the unit block of South Centre Street following the Great Fire of 1914. Box 18 sounded at 3:15 a.m. on December 17, 1914. Bitterly cold temperatures hampered firefighting efforts. A shell is all that remains of the Pennsylvania National Bank. Note the damage to the buildings on the north side of Norwegian Street (right). The cause of the fire is unknown, but it is believed to have begun in the Woolworth building, which was located in the middle of the block. (Historical Society of Schuylkill County.)

Patrolman Moyer of the Pottsville Police Department discovered fire in the Woolworth building while walking his beat on South Centre Street. He "hooked" Box 18 at 3:18 a.m. for what was to become Pottsville's greatest fire. This dramatic photograph shows the fire at its height. Firefighters from Palo Alto, St. Clair, Schuylkill Haven, and Minersville were also summoned to help contain the blaze. (Schuylkill County Historical Society.)

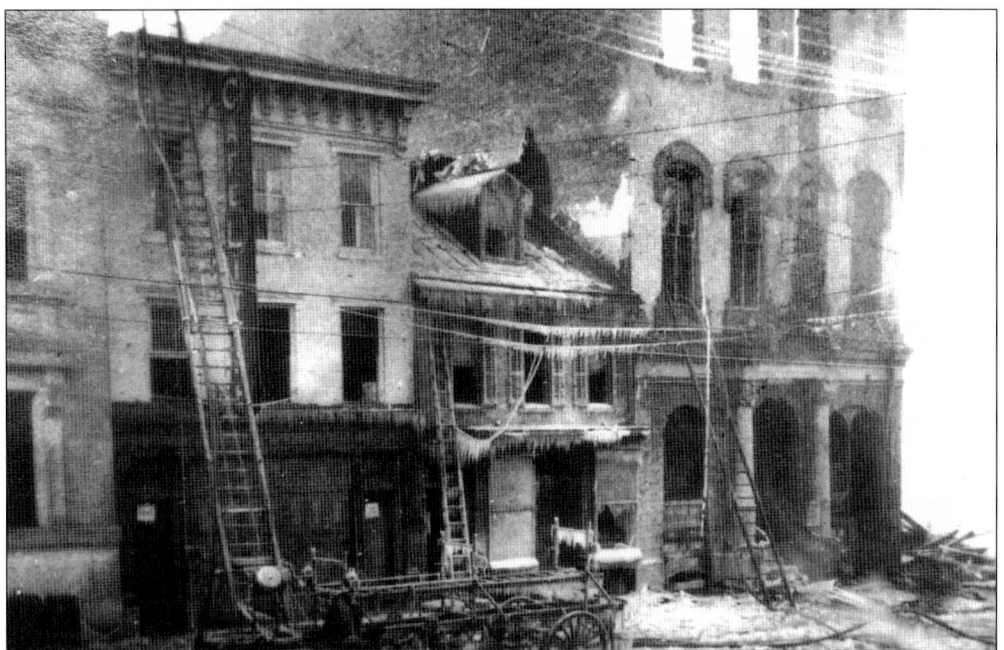

This closeup view looks northwestward on Centre Street as overhauling continues during the Great Fire on December 17, 1914. Note the gong and lanterns on Phoenix's aerial ladder truck. A hose line is stretched into the second floor of the Pennsylvania National Bank. (Historical Society of Schuylkill County.)

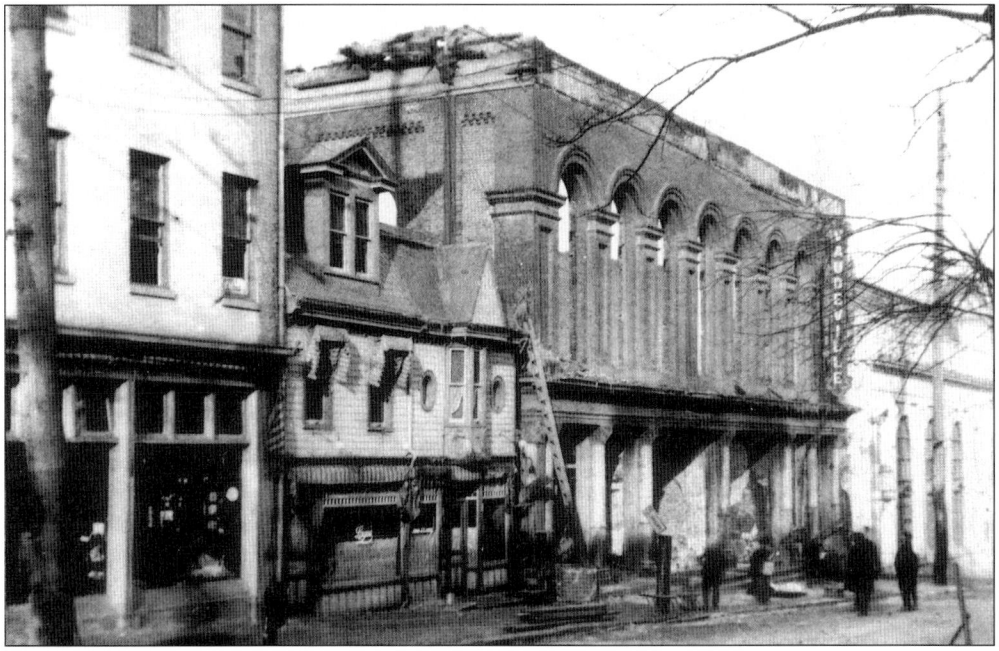

Looking at the north side of Mahantongo Street between Centre and Second, this view shows the devastated Academy of Music with the "Vaudeville" sign still visible. The building is just a shell. Although the Academy of Music was destroyed, the Union Bank (right) survived the fire. (Historical Society of Schuylkill County.)

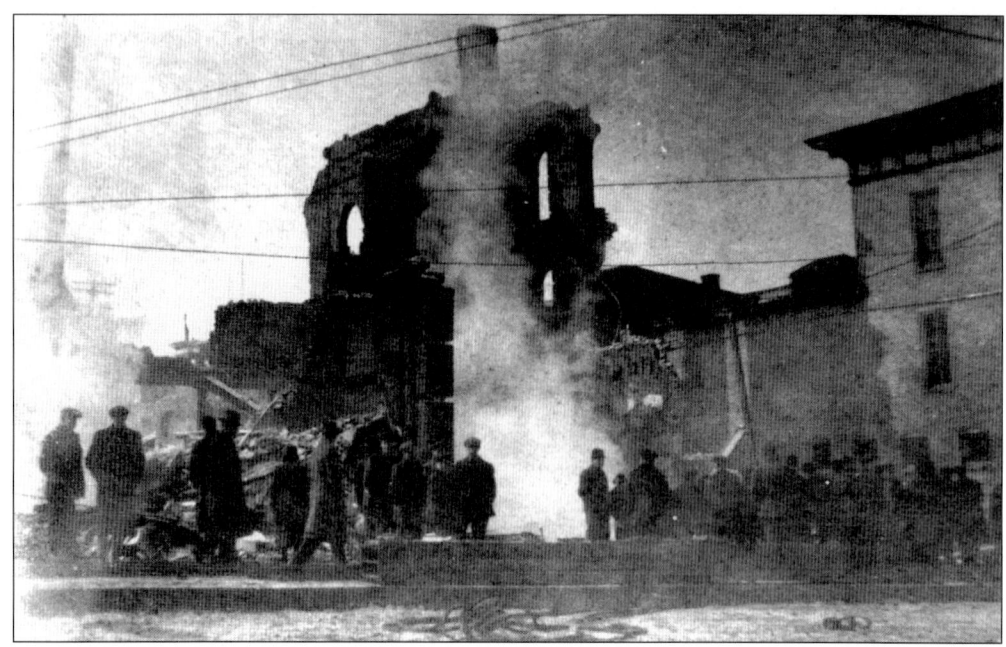

Onlookers stare in amazement at the damage at the corner of Centre and Norwegian Streets following the Great Fire of 1914. Frozen hose lies in the street as the debris continues to smolder. Only portions of walls remain in this part of the block. (Historical Society of Schuylkill County.)

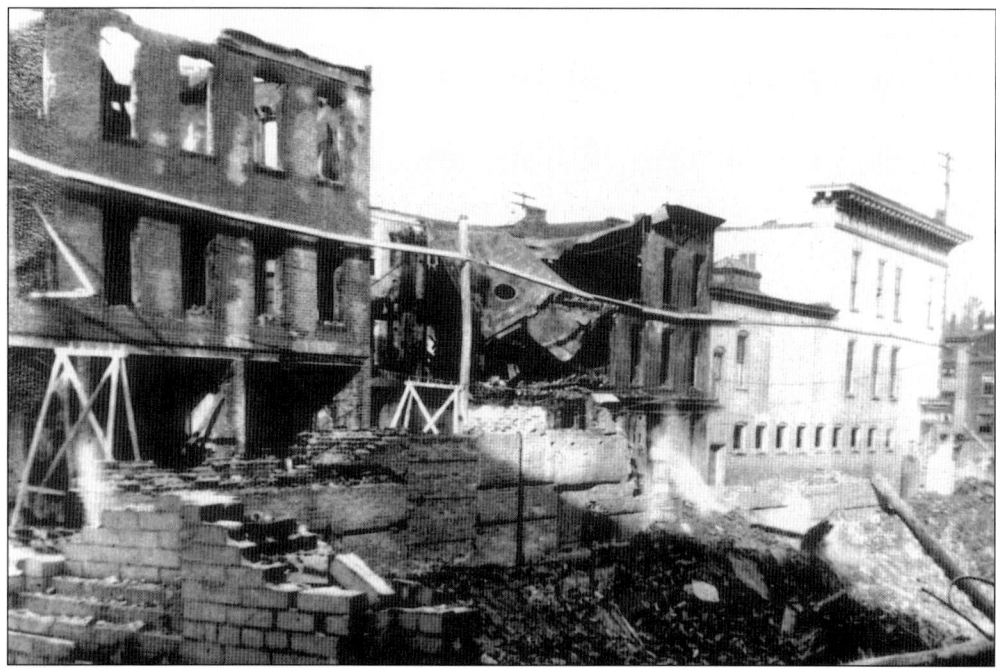

The damage to the buildings on the north side of Norwegian Street between Centre and Second is extensive. Those buildings stand on the current site of the parking lot for Community Bank. The crater in the foreground is where the J. Miehle department store once stood. (Historical Society of Schuylkill County.)

This view looks eastward on Norwegian Street across Centre Street as the cleanup after the Great Fire of 1914 progresses. The buildings on the north side of Norwegian Street have been substantially repaired. Note the horses in the excavation site (foreground). (Historical Society of Schuylkill County.)

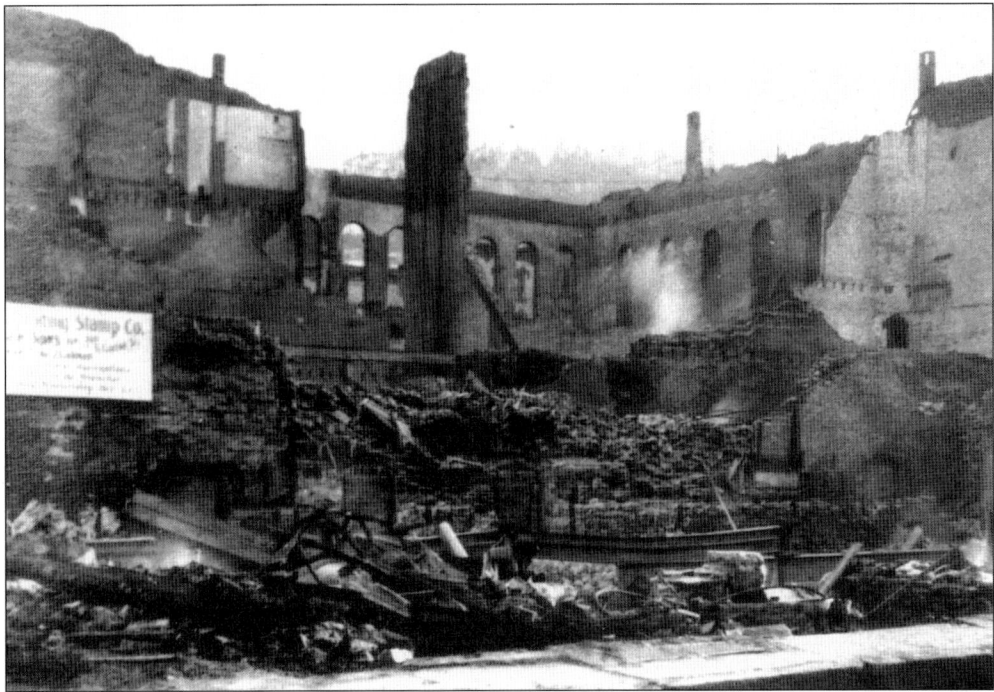

This photograph was taken looking southward from Norwegian Street through what remains of the block bordering Centre, Norwegian, Second, and Mahantongo Streets following the Great Fire of 1914. (Historical Society of Schuylkill County.)

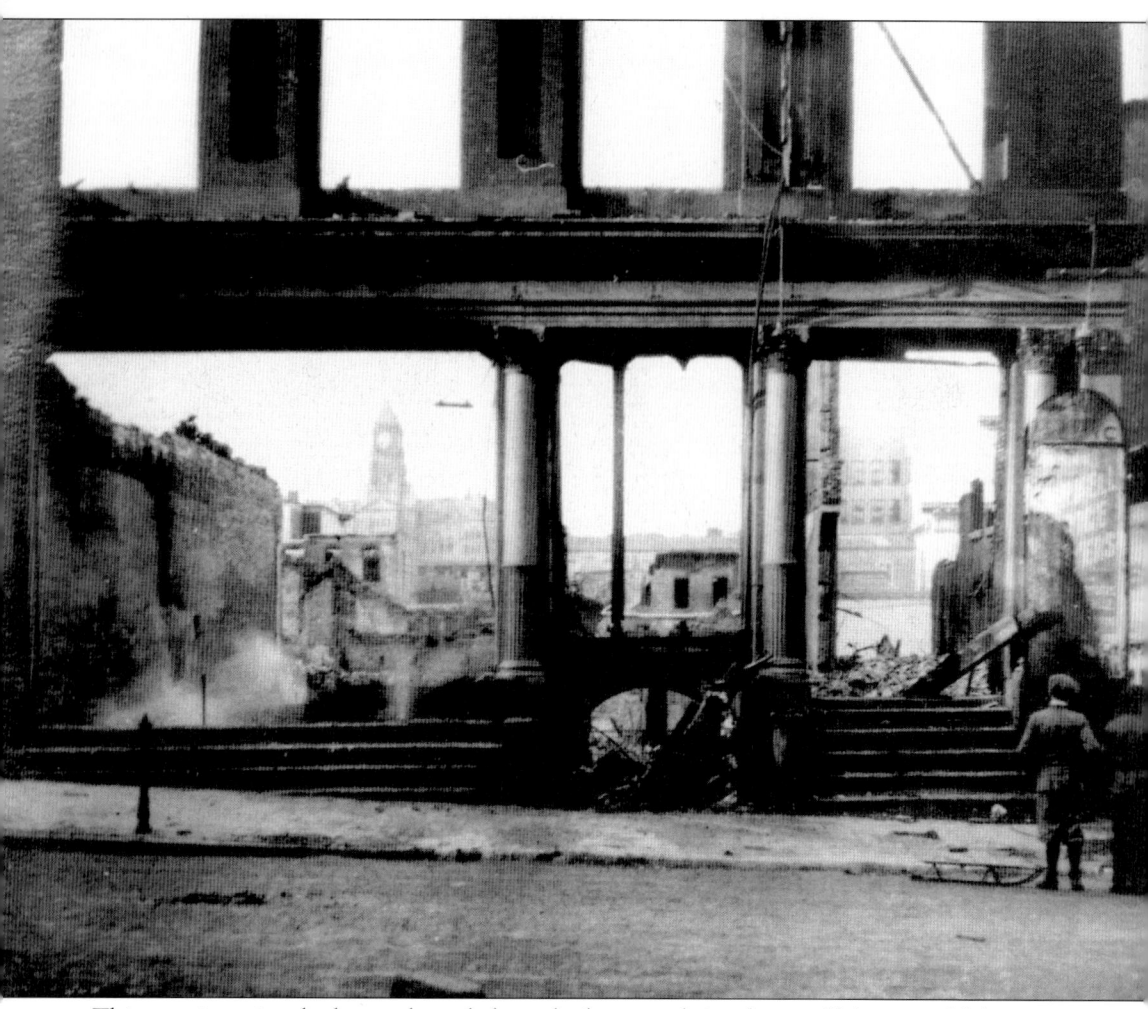

This amazing view looks northward through the gutted Academy of Music on Mahantongo Street. The Schuylkill County Courthouse is visible (background), but the time of day cannot be discerned from the courthouse clock. The two boys looking over the scene appear to be toting sleds. (Historical Society of Schuylkill County.)

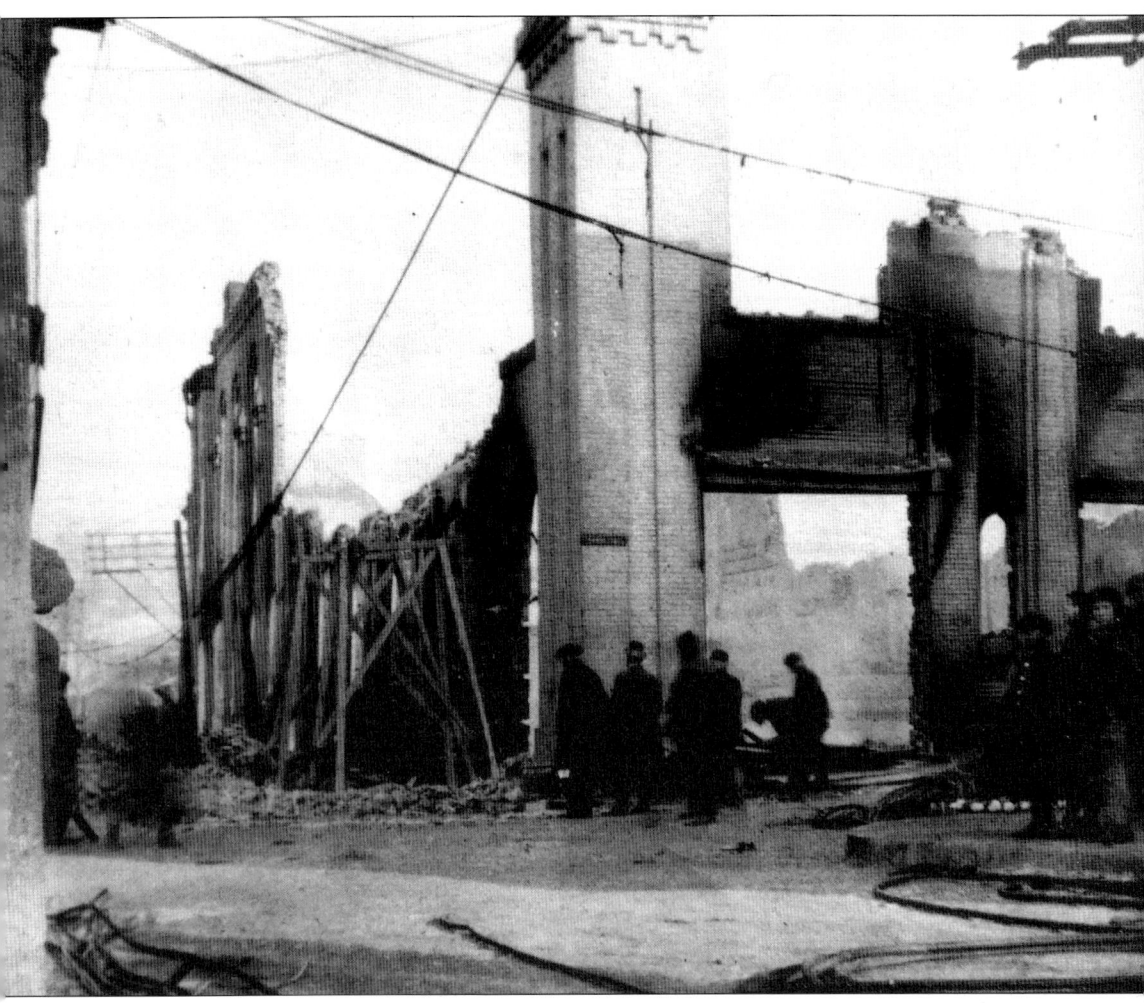

Fire hose and downed utility lines lie on the street at the intersection of Second and West Norwegian Streets. Portions of masonry walls are all that remain of the J. Miehle department store. Note the debris pile on Norwegian Street. The Masonic Building stands on the site today. (Historical Society of Schuylkill County.)

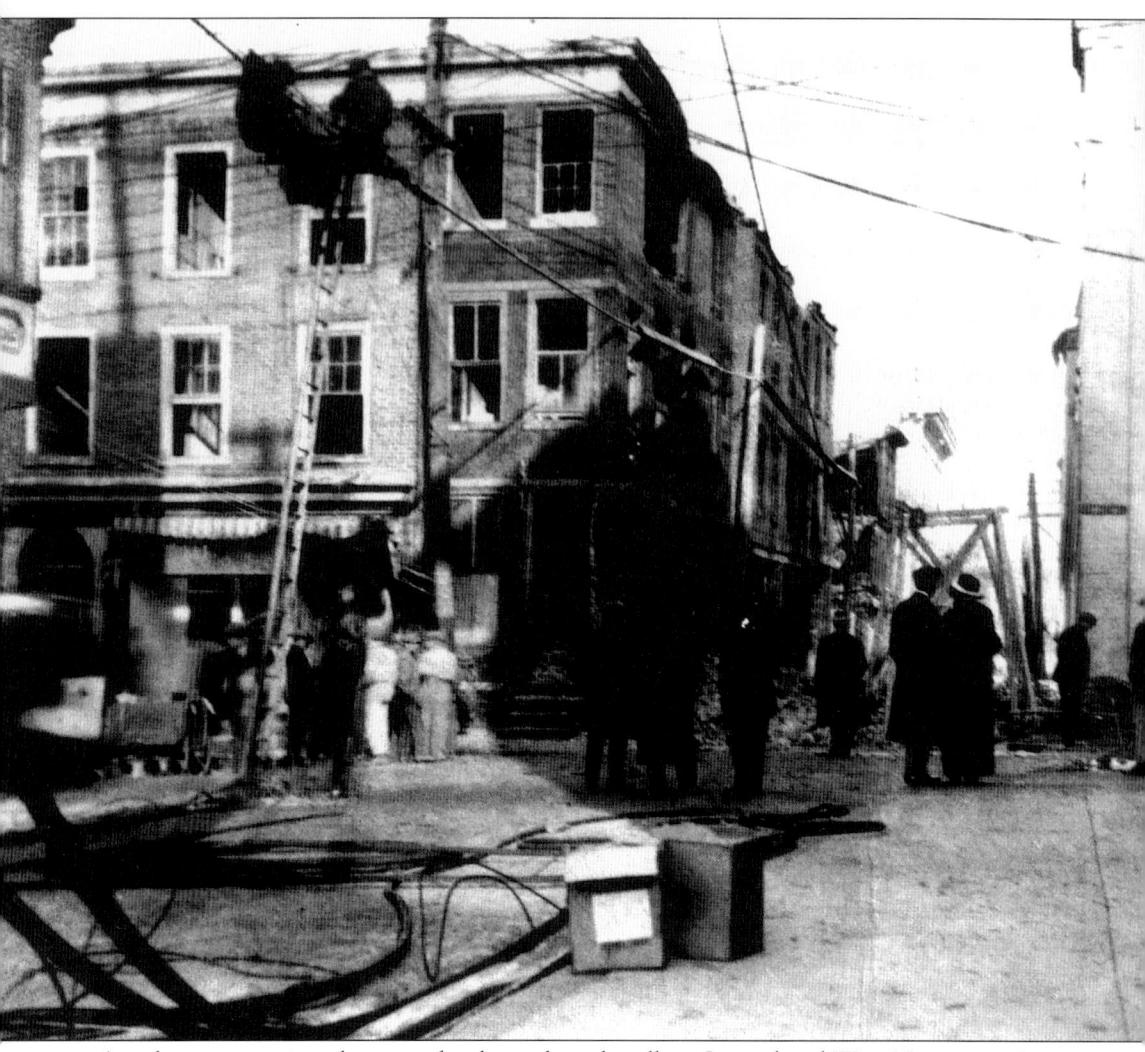

A utility company employee works above the sidewalk at Second and West Norwegian Streets following the Great Fire of 1914. Kep's Korner is located in the building on the left today. The heavily damaged buildings on the northern side of Norwegian Street are visible. (Historical Society of Schuylkill County.)

Three
THE GOLDEN ERA
1925–1955

The rapid development and widespread acceptance of the internal combustion engine led to the rapid motorization of the Pottsville Fire Department in the early 20th century. The first motorized truck in the department was a 1910 Robinson purchased by the Good Intent. By 1925, under the leadership of Fire Chief William Stevenson, all Pottsville fire companies had converted to motorized vehicles. Ironically, the first steam fire engine purchased by the fire department, an 1866 Amoskeag third-class steam engine owned by the Good Intent, is the only county survivor of the steam era. The Amoskeag is now owned by the Mountaineer Hose Company of Minersville. Stevenson retired in 1930, replaced by George Smith, Pottsville's fourth chief.

The golden era of the Pottsville Fire Department saw numerous innovative apparatus purchases by the fire companies. The most interesting trucks of this era included Phoenix's 1939 Hahn tiller ladder truck, Good Intent's 1929 Ahrens-Fox piston pumper and 1937 Ahrens-Fox triple-combination pumper, American Hose's 1948 American LaFrance 1,500-gallon-per-minute pumper, and West End's 1928 Ahrens-Fox piston pumper and 1937 Ahrens-Fox emergency car. Also interesting were Humane's 1929 Buffalo and 1953 Seagrave anniversary model open cab pumper. Other unusual apparatus included Yorkville's 1949 Maxim Quad all-wheel drive service truck and Good Will's 1953 GMC open cab high-pressure pumper. Sadly, only West End's 1928 Ahrens-Fox and Humane's 1953 Seagrave remain in the city today. Many Pottsville companies remained loyal to specific manufacturers. The American Hose Company became a faithful American LaFrance purchaser, and the Humane remained loyal to Seagrave. The West End and Good Intent favored Ahrens-Fox for many years, and Yorkville was a dedicated Maxim purchaser for many years.

World War II brought new challenges for the Pottsville Fire Department, including manpower shortages and apparatus needs. A new Pottsville fire company, the first since 1886, organized in Pottsville's Greenwood Hill section as a direct result of the war. Sector 6, Post 5 of Air Raid Wardens under Pottsville's Civilian Defense organized a social group called Group 65. This group, realizing the need for fire protection in the Greenwood Hill section, decided to form a new fire company in March 1946. On April 30, 1946, Club 65 voted unanimously to form a fire company named East End Fire Company No. 65, later changed to Greenwood Hill Fire Company No. 65. The company purchased its first truck in July 1947, an open cab International truck equipped by the W. S. Darley Company.

The expansion of the fire department also included an expansion of the Gamewell fire alarm system. More than 100 street boxes and master boxes now served the city. Additionally, Pottsville City Council replaced the Gamewell Diaphone air horn at city hall with house sirens at the eight city fire stations. City dispatchers could now activate the house sirens and transmit box alarms to all stations. During this era, many of Pottsville's fire companies also had night drivers. These men would sleep in station quarters and would serve as apparatus drivers for any incoming box or still alarms. Pottsville's golden era ended on a tragic note with the death of Phoenix member Harold Staller, Pottsville's third line-of-duty death.

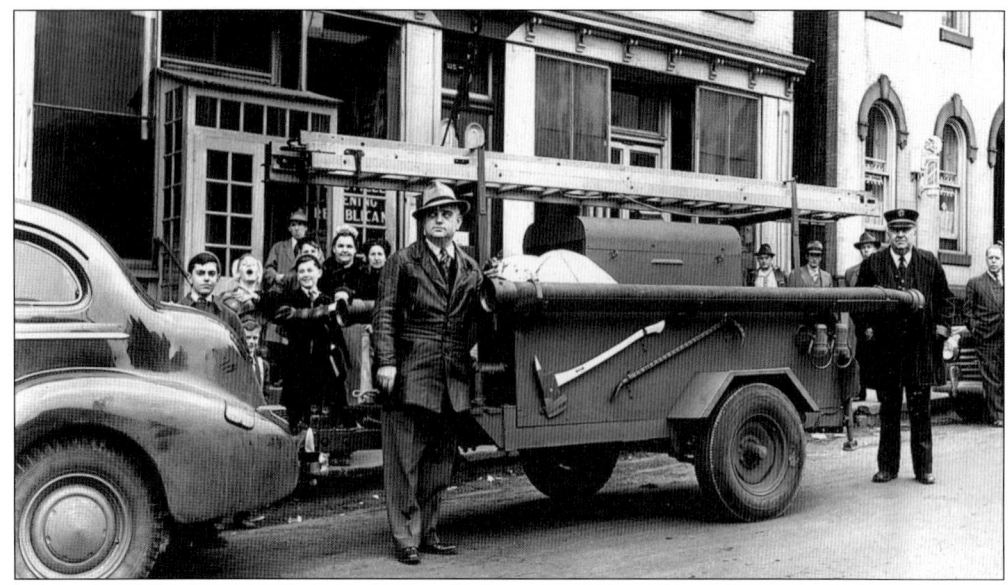

Pictured during World War II in front of the *Pottsville Republican* building, on Mahantongo Street, is Fire Chief George Smith (right, in uniform) with an auxiliary fire pump. With fire apparatus production drastically reduced due to wartime needs, these small self-contained firefighting units were a relatively inexpensive and mobile way to provide additional fire equipment to municipalities and industrial plants. The pump is being towed by Smith's vehicle.

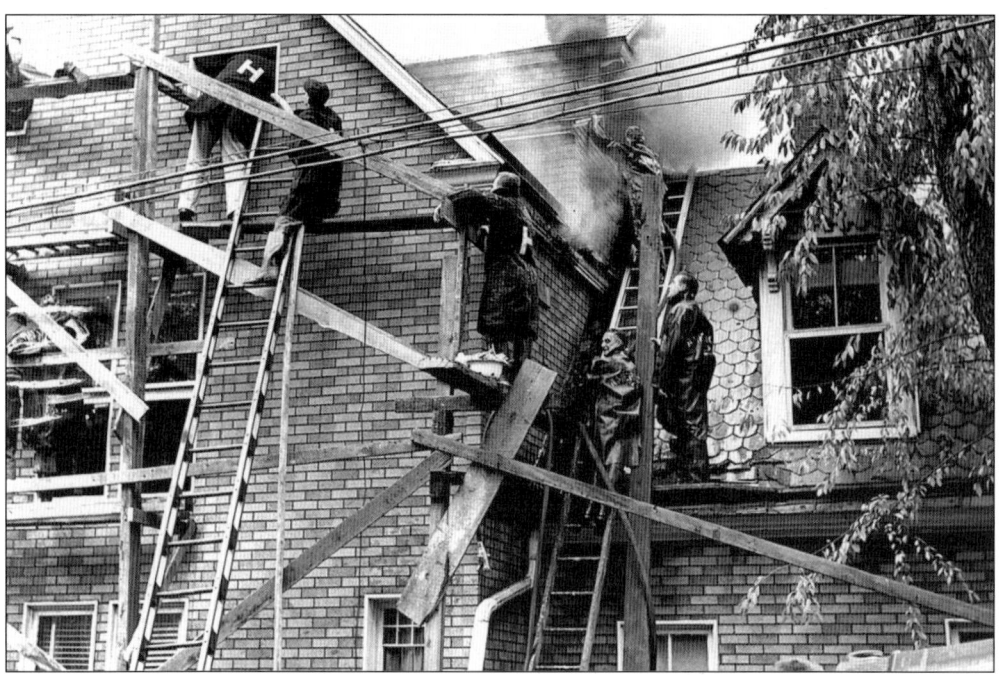

Like acrobats, Pottsville firefighters operate from wooden scaffolding erected outside this house, at 1651 West Norwegian Street. The occupant was burning rubbish in his furnace and accidentally ignited excelsior on the basement floor. Box 71 subsequently sounded at 3:07 p.m. From the basement, the fire extended vertically in the walls. (Historical Society of Schuylkill County.)

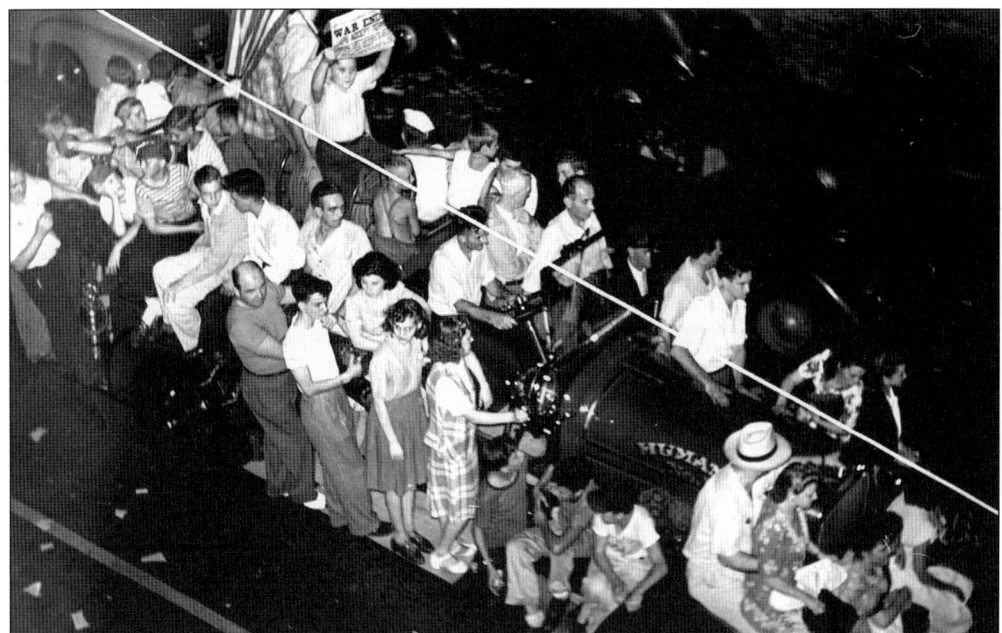

Thankfully, the department safety officer did not see this. Celebrating the end of World War II on V-J Day, August 14, 1945, Pottsville residents ride aboard the Humane Fire Company's 1921 Seagrave. While it is difficult to tell exactly, there appear to be almost 50 people on the engine. (Schuylkill County Historical Society.)

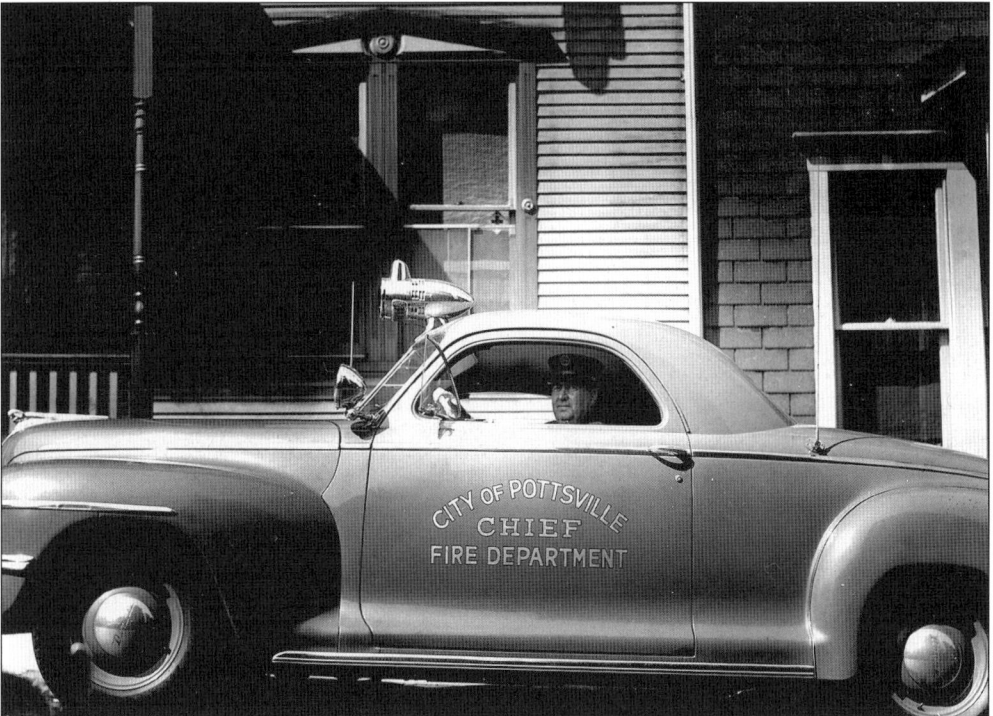

Pictured in his official vehicle is Fire Chief George Smith. Note the bullet-type red light and siren combination on the roof.

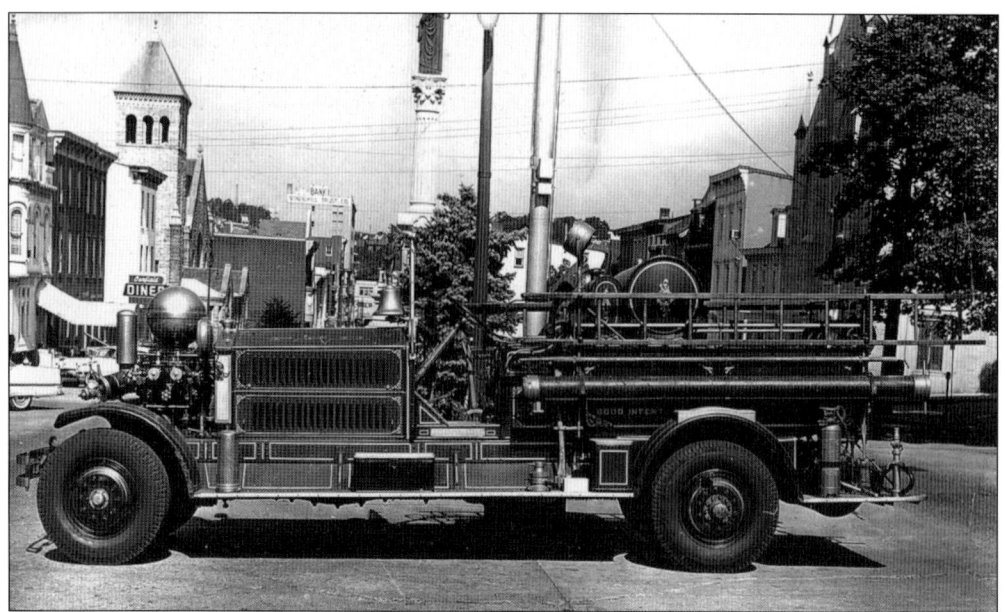

Pictured in Garfield Square just prior to being sold is Good Intent's 1929 Ahrens-Fox 1,000-gallon-per-minute piston pumper. The engine was sold on November 2, 1957, for $750 to a collector in Massachusetts. The purchaser's son owns the rig today and is in the process of refurbishing it to its original condition. West End still owns its 1928 Ahrens-Fox 900-gallon-per-minute piston pumper, which is virtually identical to this engine. (Schuylkill County Historical Society.)

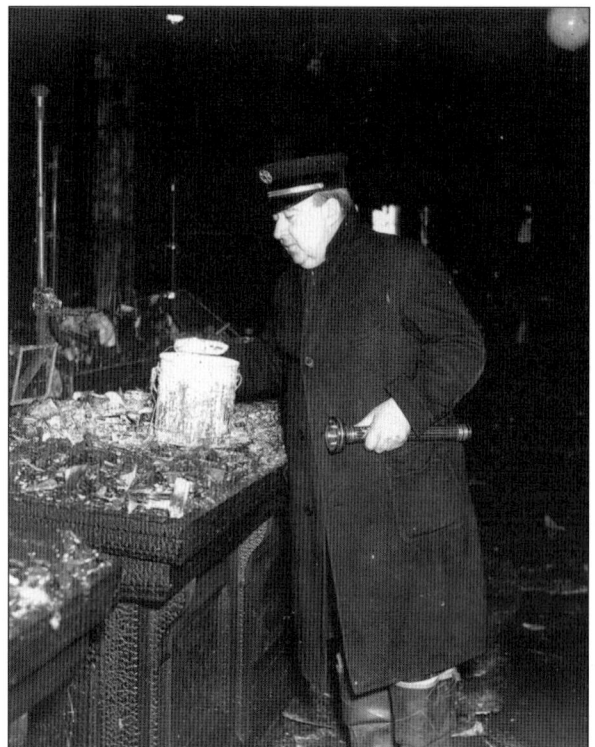

With flashlight in hand, Fire Chief George Smith conducts a cause-and-origin investigation at the Woolworth store on April 21, 1941. Box 18 sounded at 11:30 p.m. for the fire that gutted the first floor of the store and extended into the second floor via partition walls. Workers were using paint remover at the front of the store when a dropped cigarette ignited the blaze.

Looking like a scene from Boston, firefighters stretch a two-and-a-half-inch line over Phoenix's aerial ladder to the roof of the fire building. Box 18 sounded at 6:58 p.m. on November 6, 1951, for this fire, at 117–119 East Norwegian Street. The fire began in No. 119 when a cigarette ignited clothing in a closet. It then spread to the roof and to No. 117. Damage totaled $14,601. (Phoenix Fire Engine Company No. 2.)

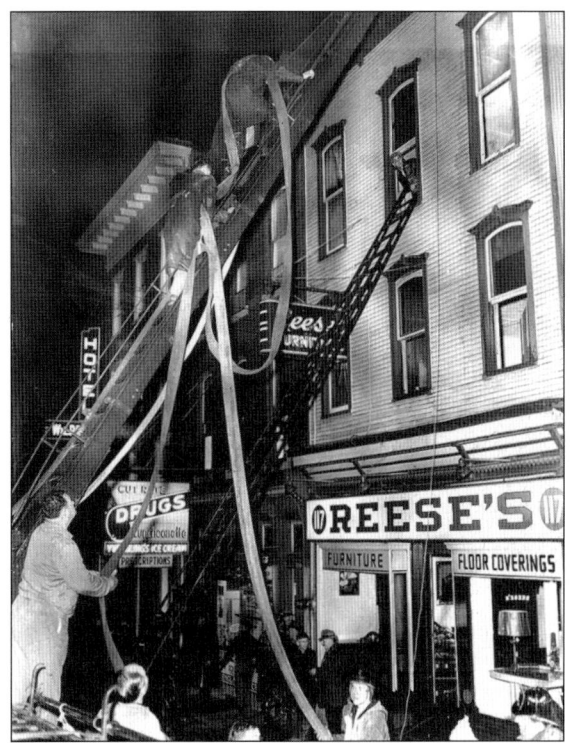

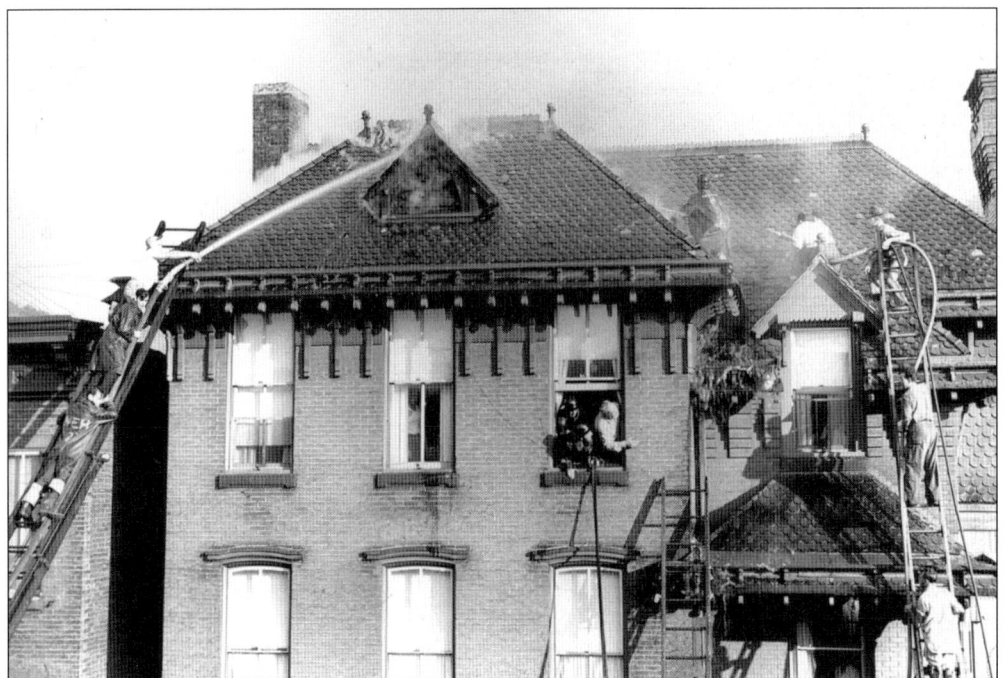

Operating from the interior of the building, as well as from ground ladders and Phoenix's 75-foot wooden aerial ladder (left), firefighters battle this top-floor fire at the Elks Lodge, located at 313 Mahantongo Street. Box 36 sounded at 6:12 p.m. on August 24, 1946. The loss was placed at $7,659.82. The building still stands—minus the top floor.

35

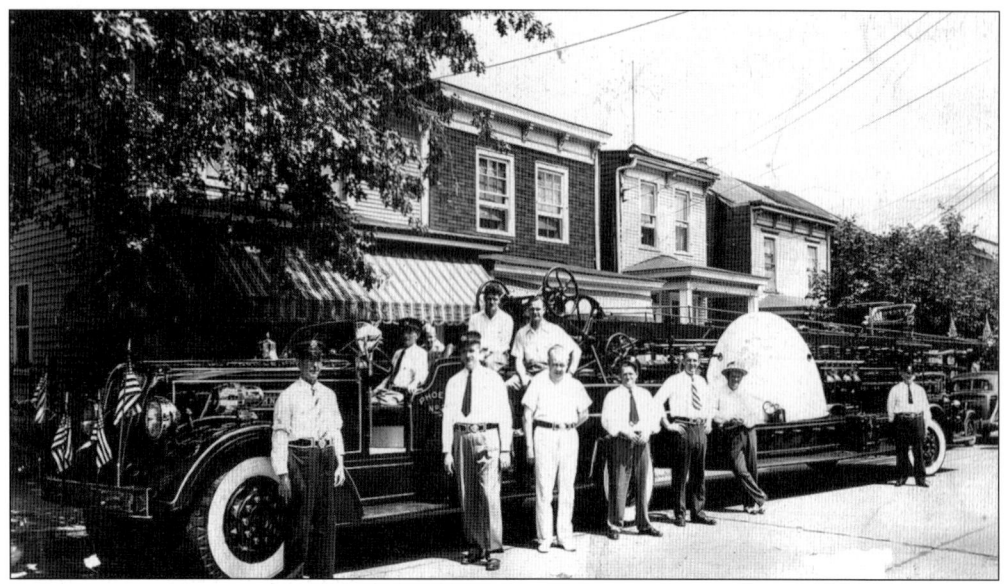

Phoenix Fire Engine Company No. 2 members pose proudly in front of their 1939 Hahn tractor-drawn 75-foot wooden aerial ladder truck. The Phoenix is in parade form, with members wearing uniform belts and American flags on the front of the apparatus. The life net is under the large white cover on the side of the rig. The wooden aerial ladder is from Phoenix's 1919 American LaFrance. Phoenix carried 252 feet of ground ladders, as well as the 75-foot main aerial ladder. (Phoenix Fire Engine Company No. 2.)

The mechanics of the raising mechanism on Phoenix's 75-foot aerial ladder are clearly visible in this photograph, taken at the scene of the Woolworth fire on December 2, 1950. The company has the ladder pipe in service, directing a stream into the upper floors of the building. The supply line to the ladder pipe can be seen snaked up the underside of the aerial ladder. (Phoenix Fire Engine Company No. 2.)

Fire started in a small room on the second floor of 405 Howard Avenue on September 19, 1956, and Box 32 sounded at 12:29 p.m. Firefighters have booster lines stretched over the porch roof, as seen in this photograph, taken from atop Phoenix's aerial ladder truck. The wooden aerial ladder and tillerman's seat are visible in the lower left. St. Joseph's Church can be seen in the background.

As part of a statewide air raid drill held in 1952, Pottsville firefighters demonstrated rescue techniques at a simulated burning building. The drill was held at 210 South Centre Street. In the photograph, firefighters from the Phoenix demonstrate the use of their 65-foot evacuator, which was used as a chute to rescue trapped occupants. Members of the Pottsville Junior High School football team served as some of the victims. (Phoenix Fire Engine Company No. 2.)

This view shows some vintage apparatus. In the thick of things is West End's one-of-a-kind 1937 Ahrens-Fox emergency car, painted forest green. Although it looked like an ambulance, the vehicle was actually a 500-gallon-per-minute pumper with a 100-gallon booster tank. Units are operating at Box 51 at 2:09 p.m. on December 3, 1952. A flash fire in a workshop damaged the Eagle Grill and Freedman's Store, at 321 North Centre Street. (Phoenix Fire Engine Company No. 2.)

Having knocked down the bulk of the fire, firefighters use booster lines while overhauling this outbuilding, used to store old paper, at the rear of the Sears Roebuck store on South Centre Street. The loss was placed at $1,000. Box 26 sounded at 3:50 p.m. on March 11, 1953.

Firefighters remove a burning mattress from the second-floor apartment at Second and West Norwegian Streets as other firefighters advance hose lines over ladders to the floor above. Box 36 sounded at 8:10 a.m. on April 5, 1955. The fire originated in an apartment on the second floor. Badly burned, Isabel Harvey was removed from the apartment and died at the Pottsville Hospital at 8:55 p.m. the same day. Rose's Cigar Store occupied the first floor—the current site of Kep's Korner.

Working off the rear balcony of the Dunn apartment house, known as the Flats, a firefighter from Yorkville and another member toss a burned sofa to the yard below. Protective gloves were optional at the time. Box 57 sounded at 4:25 p.m. on New Year's Day 1951 for this fire, which caused $3,000 worth of damage.

This was one of the many fires that struck the Flats—so named because of the configuration of the apartments—over the years. Judging by the charring of the window frame and the underside of the balcony, firefighters were likely confronted with a good fire venting from the rear of the building upon arrival on January 1, 1951. This view overlooked the 400 block of North Centre Street.

40

Firefighters from Greenwood Hill Fire Company and American Hose Company operate from the roof of the exposure building in the rear of the Melody Bar-Keim's Card Shop fire. Heavy fire is venting from the rear roof of the building, which fronts Market Street. Access to the rear was gained from North Second Street.

A firefighter from the Good Will Fire Company vents the front display window of Keim's Card Shop, at 113–115 South Centre Street. A cautious fire attack is mounted into the store under obviously tenuous conditions. The entrance to the Melody Bar can be seen at the far right.

Massive damage occurred at the Melody Bar, where fire originated on November 29, 1953. Box 18 sounded at 4:58 a.m. for 113–115 West Market Street. The cause of the fire is unknown, but the Melody Bar sustained $10,000 in damage, and the loss to all occupancies was $115,516.

Judging by the debris on the floor, firefighters from the Phoenix are operating inside the Reading Hose Outlet, in the 113–115 West Market Street complex. Better known as the Melody Bar Fire, this disaster ravaged more than 19 businesses, offices, and apartments. The building was struck by fire again in 1989, and a dentist's office was heavily damaged.

Hose line spaghetti is in the street, and Phoenix's 75-foot wooden aerial ladder has the pipe prepared to battle this blaze, which devastated 113–115 West Market Street. Box 18 sounded at 4:58 a.m. on November 29, 1953, for the fire originating in the basement of the Melody Bar.

Fire Chief George Smith emerges from the rear of the Trudy Shoppe, at 5 North Second Street, where firefighters are in the process of extinguishing a fire that began in the rear stockroom of the store. These smoke-eaters work low under the smoke with no personal protective equipment. Scorch marks are evident, as is blistered paint on the double doors, which are open to allow access to the rear of the building.

Humane Fire Company's 1929 Buffalo hose and booster truck is ice encrusted as it is backed into quarters. The rig is returning from Box 45, sounded at 9:40 a.m. on February 12, 1955, for a fire at 810–814 Vine Street. The fire, likely caused by a defective chimney, resulted in $6,866 worth of damage. The Schuylkill County Courthouse can be seen in the background. (Humane Fire Company No. 1.)

Smoke pushing from the eaves and window frames indicates a fire that is running the walls in these wood-frame row houses, at 527, 527 1/2, 529, and 531 East Market Street, on October 23, 1954. Box 16 sounded at 12:37 a.m. for the fire, which began in the basement of No. 529 and extended through the interior of these dwellings. Firefighters work over ladders in the rear of the buildings.

This fire, a little too close for comfort, started in the rear stockroom of the Trudy Shoppe, at 5 North Second Street, right next door to the Good Intent Fire Company, at 7 North Second Street. Box 14 sounded at 3:05 p.m. on February 21, 1957. A line from the hydrant in front goes directly into the engine room to the apparatus that pumped from its quarters. Note the hose-drying racks on the engine room wall.

45

With helmet turned backwards, this smoke-eater calls for the booster line to press an interior attack on this fire, which damaged 414–414–418 Minersville Street. The fire began in the back of a heater stove in No. 416 and burned through the partition walls and ceiling to the top floor. Box 53 sounded at 8:15 p.m. on January 29, 1952.

American Hose's 1952 American LaFrance 750-gallon-per-minute pumper is in the foreground of this fire scene on Mahantongo Street on April 10, 1953. Behind this rig, at the corner of Second and Mahantongo Streets, is American Hose's 1948 American LaFrance 1,500-gallon-per-minute pumper. Off to the right is the rear of West End's 1937 Ahrens-Fox 500-gallon-per-minute emergency car. (Schuylkill County Historical Society.)

Minersville Street kept firefighters busy for many years until urban renewal essentially eliminated the street in the 1960s. Here, firefighters work over ladders at the January 29, 1952, fire. The three properties sustained $1,850 damage. The nose of Humane's 1929 Buffalo hose and booster truck can be seen at the lower right.

Humane members pose proudly with their new 1953 Seagrave 70th-anniversary series 1,000-gallon-per-minute pumper. The engine is still owned by the Humane and is in excellent condition. The engine carries a 200-gallon booster tank, and it had 1,600 feet of two-and-a-half-inch hose when placed in service. Note the child peering from behind the engine's imposing fender. (Humane Fire Company No. 1.)

Fire Chief George Smith served the Pottsville Fire Department well. A member of the Good Intent Fire Company No. 1, Smith was appointed in July 1931 and served until 1958, when Chief Andrew Hoke of the Greenwood Hill Fire Company was appointed. Smith was a veteran of the Great Fire of 1914. In his 27 years of service, he commanded some of Pottsville's most spectacular fires and guided the department through the World War II years.

Four
COMING OF AGE
1956–1969

The Pottsville Fire Department, now eight companies strong, thrived in this era while the fortunes of the city dwindled. The post–World War II and Korean War periods locally saw increased unemployment, the collapse of the anthracite industry, the decline of the Reading and Pennsylvania Railroads, both serving Pottsville, and the stagnation of the business district. The city also witnessed a significant drop in population as job opportunities diminished. Despite these local economic woes, the Pottsville Fire Department upgraded its vast fleet with numerous important purchases and dedicated a new fire station, new social quarters, an apparatus room addition, and a new apparatus building. Additionally, the Gamewell fire alarm system was extended through additional areas of the city. At this time Pottsville fire companies also became strong supporters of the newly organized Schuylkill County Volunteer Firefighters Association. Pottsville sponsored its first Schuylkill County Firefighters' Convention in 1959.

In 1958, Good Intent Fire Company purchased a new Oren triple combination pumper, its first new purchase since the Ahrens-Fox acquisition of the 1930s. In 1959, the Phoenix Fire Engine Company purchased a 100-foot American LaFrance tiller-driven aerial ladder truck. This aerial served Pottsville for more than 40 years. In May 1957, Yorkville Hose & Fire Company purchased the property on which its original fire station stood and broke ground for a new apparatus building. The growth and expansion of the Yorkville section of the city prompted added fire protection measures. Yorkville also placed a new Maxim Quad truck into service in 1967. On January 21, 1960, the American Hose Company broke ground for its new social quarters adjoining its engine room on Norwegian Street. A dedication followed later that year.

The fire company exhibiting the most significant changes in this era was the Humane Fire Company. Humane not only made new Seagrave apparatus purchases in 1953 and 1964 but also moved into its new fire station at Third and Laurel Streets in 1969. The 1953 Seagrave was an open cab engine with a 1,000-gallon-per-minute midship pump. This pumper still serves the Humane today. The 1964 was a 200-gallon-per-minute special service truck built on a short chassis, reportedly one of only three built by Seagrave. Humane members desired a short chassis truck for navigating the narrow streets and alleys in their fifth-ward primary coverage area. Pottsville's fourth firefighter fatality occurred in 1962, with the heart attack death of Harold Staller, a West End Hose Company member.

Greenwood Hill Fire Company No. 65 also remained very active during this era. An addition was built onto its engine room to house a new fire truck, a 1966 Hahn 750-gallon-per-minute pumper on an International chassis. Likewise, the Good Will Fire Company made two apparatus purchases during this era: a 1963 GMC and a 1965 GMC, both high-pressure pumpers. The West End made two Seagrave acquisitions in the early 1960s: a 1960 Aerial Quint 65-foot, 750-gallon-per-minute truck and a 1963 model 750-gallon-per-minute pumper. The only Pottsville fire company not making a new apparatus purchase was the American Hose Company. American Hose's two American LaFrance pumpers—one 1,500-gallon-per-minute and one 750-gallon-per-minute—continued to provide fine engine company service throughout this era. The Pottsville Fire Department was entering the 1970s in excellent condition. Also in this era, Andrew Hoke replaced the retiring George Smith as fire chief in 1958.

Firefighters press the attack into the Acme Markets store at Sixth and West Market Streets on October 27, 1959. A still alarm for the Good Intent and American Hose at 10:00 p.m. was quickly followed by Box 42 at 10:05 p.m. as arriving companies encountered an advanced fire and rapidly deteriorating conditions.

Assistant Fire Chief Jack Flannery of the Good Intent dons a Scott self-contained breathing apparatus as he prepares to enter the heavily charged Acme store on October 27, 1959. Note the aluminum Cairns helmet turned backward, which was customary practice for many years when closing with the fire. The firefighter to the right in the doorway looks to be dressed for the party—but not this one.

A victim, likely a brother firefighter, is removed over a ladder from the roof of the Acme Supermarket at Sixth and West Market Streets. A still alarm at 10:00 p.m. was followed by Box 42 at 10:05 p.m. The result of the fire was $150,000 of damage.

Ladders are up, and big lines are brought into service as crews opt for an exterior attack. The Acme Market was destroyed, with damage totaling $127,000. An apartment occupied by Art "Scoop" Felsburg was also destroyed, with a loss of $23,000. Firefighters earned high praise for saving the English Lutheran Church and parish house, which was next door to the store.

Firefighters from Yorkville Hose advance a two-and-a-half-inch hand line over a ladder to be directed into the upper windows of the automobile dealership. Other members operate hose lines into the display area in the background.

Yorkville's 1949 Maxim Quad 750-gallon-per-minute pumper goes into service as heavy smoke pours from the Rapp Motor Company in the 2200 block of West Market Street, the present site of Hadesty's Hardware Store. Box 78 sounded at 5:45 p.m. on June 15, 1959.

A firefighter examines a destroyed automobile that was in the showroom of the Rapp Motors Company. Note how gingerly he steps in the water that has accumulated on the floor as he is wearing dress shoes, not boots. Overhauling continues in the background.

Shown is good general view of the Rapp Lincoln, Mercury, and Continental automobile dealership, on West Market Street. Firefighters continue overhauling on the roof and inside the business. The June 15, 1959, fire caused $100,000 in damage.

The walls are opened up to expose the fire in the rear of the building as booster lines and a one-and-a-half-inch hand line are brought onto the back flat roof (background). The fire at 110 North 12th Street was caused by an overheated circulating room heater and resulted in $4,000 worth of damage. (Historical Society of Schuylkill County.)

Humane's foreman ascends to the roof of this dwelling, at 110 North 12th Street. Note that he is wearing his protective "fedora." The smoke condition indicates a fire concealed in the walls. A still alarm at 8:05 p.m. was quickly followed by Box 41 at 8:10 p.m. on December 20, 1962.

West End's 1937 Ahrens-Fox emergency car responded to Box 41 at 308 North 12th Street at 9:03 p.m. on September 10, 1956. The fire in the front bedroom on the second floor caused $1,357 in damage. Box 41 sounded again for 308 North 12th Street at 10:56 p.m. on February 5, 1985, for a fire that gutted the third-floor bedroom as a result of a child playing with matches.

Foreman Jerry Brennan operates the Hardie gun nozzle on Good Intent's booster line as Fire Chief Andrew Hoke supervises operations at Troutman's Pontiac, at Third and West Race Streets, on August 26, 1962. The still alarm was sounded at 2:00 p.m. Some 10 years later, after what became famous as the Pottsville Showcase fire, the building no longer stood.

55

Good Intent's 1958 Oren 750-gallon-per-minute pumper is tended to by pump operator George Seiders at this fire on June 6, 1963. Box 57 sounded at 3:00 p.m. for 713 North Second Street. American Hose's 1952 American LaFrance 750-gallon-per-minute pumper is also in view.

Probably owing to the warm season, these smoke-eaters utilize no personal protective equipment as they operate in the rear entrance of 713 North Second Street. It appears that a booster line is stretched into the rear entrance. The cause of the fire was not determined.

A fire officer dons a Mine Safety Appliances (MSA) all-purpose filter-type mask next to Humane's 1929 Buffalo hose and booster truck at the 713 North Second Street fire on June 6, 1963. Although the "H" on the boots clearly indicates Humane equipment, judging by the color and style of the protective turnout coat and helmet, this might well be Fire Chief Andrew Hoke. (Schuylkill County Historical Society.)

The white tips indicate that Good Will's apparatus provided these ladders at the January 9, 1957, residential fire at 744 Water Street. Numerous hose lines are stretched into the private dwelling to put out the fire that began when papers piled too close to the ceiling ignited. Note the firefighter donning the Scott self-contained breathing apparatus on the porch and the open apparatus case on the wall in front of the home.

Box 614 sounded at 2:20 p.m. on January 9, 1957, for a fire at 744 Water Street. Notice the children watching the action from the porch of the attached exposure building next door. The fire loss totaled $4,363.98.

The glow from the burning Amor Fraterno club illuminates the southeastern corner of Pottsville on December 18, 1960. Box 24 sounded at 1:50 a.m. for the building at the corner of Mauch Chunk and Hamilton Streets. The loss was estimated at $70,000. Ehrlich Pest Control is still there. Schuylkill Pediatrics now occupies the location where the Amor Fraterno building once stood. (Historical Society of Schuylkill County.)

Phoenix's new 100-foot American LaFrance tractor-drawn aerial ladder is in service in front of the Amor Fraterno club, on Mauch Chunk Street. The cause of the fire is unknown. The hydrant location could not have been better. Note the pair of two-and-a-half-inch supply lines running from the hydrant. How times have changed. (Historical Society of Schuylkill County.)

59

Crews from Yorkville direct a heavy stream into the well-involved top floor of the Hobbs home, at 1417 Mahantongo Street. The first alarm for Box 33 sounded at 8:40 p.m. on December 20, 1966. Firefighters returned at 3:30 a.m. on December 21, 1966, as well. Damage to the stately home totaled $86,500.

A city assistant fire chief ascends a ladder as numerous streams are directed into the rear of the top floor of the Hobbs home. Although the home was devastated by fire shortly before Christmas 1966, the house still stands today very handsomely on Mahantongo Street.

This view, taken from atop Good Intent's 1958 Oren pumper, shows significant fire on the top floor of the Hobbs home. The scorching of the brick and stone around the second-floor windows indicates that the fire had also run its course in that area. Still alarms were sounded for rekindles at 7:50 a.m. and 3:00 p.m. on December 21, 1966.

From Pine Grove to Auburn to Middleport to Mahanoy City to Shenandoah to Minersville, West End's 1960 Seagrave 65-foot Quint 750-gallon-per-minute pumper was a true workhorse and took in many working fires both in Pottsville and throughout Schuylkill County. The rig was purchased at a cost of $45,880 and served for 17 years. It was sold in 1977 to the Green Ridge Fire Company in Aston. West End's pride is shown here in parade form, complete with a floral arrangement affixed to the front bumper.

61

These frame homes at 514–516–518–520 Laurel Street were in flames when companies arrived on May 12, 1963. To the left in the photograph is West End's 1960 65-foot Seagrave Quint, with the ladder pipe in operation. Crews are also stretching a line over a ground ladder onto the exposure building on the right. The four homes sustained $15,000 in damage. (Historical Society of Schuylkill County.)

Assistant Chief Leland Long barks orders as crews operate inside the Liberty Oil garage, on South Second Street. A still alarm was followed by Box 36 at 8:20 p.m. on March 22, 1965. The service station sustained $2,300 damage in the fire.

62

The Saylor Lumber Company was on the border of Pottsville and the borough of Palo Alto. On March 27, 1964, it was destroyed by fire. Box 27 sounded at 4:50 p.m. for the raging blaze that destroyed the lumberyard. Along with the eight city companies, the Palo Alto Fire Department was also on the scene.

Firefighters from Humane, Greenwood Hill, and West End work to put a two-and-a-half-inch hand line in service through the brick office portion of the Saylor Lumber Yard. The framing is all that stands of the lumber storage structure to the right. Note the heavy charring on the window shutters.

63

Firefighters knock down the fire in the roof area of the Leed Foundries, at 125 West Railroad Street. Box 63 sounded at 12:03 a.m. on September 4, 1962. This spectacular fire caused $10,000 in damage. The fire log of the Good Intent Fire Company puts it simply: "Flames on Arrival."

On September 4, 1962, crews from Humane and Good Intent direct their efforts toward the roof of the Quirin Foundry, formerly Leed Foundries, at 125 West Railroad Street. Significant charring of the roof beams is evident. Today's firefighters would view this operation as a pretty good trench cut.

Here is an overall view of the September 4, 1962, Quirin Foundry fire. It is evident that, upon arrival, companies encountered a heavily involved commercial building.

Everyone loves a brush fire. This one burned a shed, too. Several booster lines are used to soak the area on Railroad Street in Pottsville's Jalappa section. Box 63 sounded at 11:35 a.m. on March 29, 1962.

65

Humane's 1929 Buffalo booster and hose truck is parked in front of 120 West Railroad Street on November 8, 1961. Box 68 sounded at 9:25 a.m. for a fire that caused $800 in damage. A defective flue caused the fire.

This is about as much Pottsville fire apparatus as can be packed into one photograph. Six of the eight Pottsville fire companies are represented in the picture, which was taken from atop West End's 1960 Seagrave Quint. Also included is Fire Chief Andrew Hoke's 1958 Chevrolet chief's vehicle, which was received new on January 16, 1958. Wonder why it was called Railroad Street? Note the tracks to the right.

Firefighters from the Humane run a ground ladder up as a firefighter from the Good Intent dons his all-purpose mask for this fire at 220 North 11th Street. Box 41 sounded at 4:10 p.m. on October 11, 1956. Neighborhood boys who had set rubbish on fire in the basement caused the fire. The fire loss was estimated at $1,028. Two booster lines and a single one-and-a-half-inch line are run up the front steps of the home.

Manning the nozzle, Bob Scheipe of the Good Intent Fire Company hoses down fuel from a collision involving a fuel tanker and an East Penn bus at the intersection of Route 61 (Claude A. Lord Boulevard) and Mauch Chunk Street. The still alarm was sounded at 4:00 p.m. on April 25, 1961. (Schuylkill County Historical Society.)

67

Fire caused $6,300 damage to the homes at 1204–1206–12081–1029 West Arch Street on March 24, 1962. Box 41 sounded at 8:09 a.m. for the fire in this row of frame houses, which was caused by a defective chimney. West End's aerial ladder has been run to the roof as firefighters work to cut off the spread of the fire in the cocklofts.

This ladder work might rival that which has made the Boston Fire Department famous. Numerous ground ladders have been run at the row of frame houses in the 700 block of West Race Street. The fire caused $6,000 damage to 718–720 West Race. The cause is unknown. Box 54 sounded at 12:48 p.m. on August 29, 1961.

On June 23, 1965, fire heavily damaged the buildings at 501–503–505–507 Minersville Street. Box 53 sounded at 6:05 p.m. The buildings were vacant and owned by the Pottsville Redevelopment Authority. These acquisitions by the Redevelopment Authority spelled the end of Minersville Street. From 1940 to 1969, Box 53 sounded for 27 working fires on Minersville Street.

Despite the heroic efforts of Pottsville firefighters, a baby girl died on the third floor of 109 South George Street on July 17, 1965. A candle caused the fire. Box 17 sounded at 11:40 p.m. In this photograph, hose lines are advanced over ladders in the rear of the row of frame houses.

Fire Chief Andrew Hoke directs the troops as fire from the rear of this heavily involved frame building extends to the exposures. Vacant buildings owned by the Pottsville Redevelopment Authority at 501, 503, 505, and 507 Minersville Street were gutted. Box 53 sounded at 6:05 p.m. on July 23, 1965.

Phoenix's 100-foot aerial ladder is in the foreground, and West End's 65-foot aerial is in the background—both up to the roof. Good Intent's 1958 Oren is on the left. This fire at the Plaza Hotel, at Railroad (now Progress Avenue) and East Norwegian Street, caused $27,500 worth of damage. Box 19 sounded at 12:34 a.m. on June 25, 1966, the last day of the Phoenix block party, as noted on the advertising sign on the side of its ladder.

The Warne Hospital was located at Second and Mahantongo Streets in Pottsville. On July 19, 1963, the awnings at the back caught fire. Although the awnings were fully involved, the alarm was held to a still, with no box number sounding for the fire. The time of the fire was 3:50 p.m., and companies were in service for approximately 45 minutes.

This home on Hillside Road was destroyed on May 28, 1968. Box 38 sounded at 12:30 a.m. The loss was placed at $5,000. A still alarm at 7:20 a.m. was needed for a rekindle. A significant relay of two-and-a-half-inch hose was necessary to get water to the fire, which was in a relatively remote southwestern part of the city.

American Hose's 1952 American LaFrance pumper operates at this row of frame houses on Wheeler Street. Box 112 sounded at 12:08 a.m. for 421–423–425–427 Wheeler Street. Wheeler Street is located on an extremely steep hill on the east side of Pottsville. Water-pressure problems hampered operations. All four homes were destroyed.

The damage is evident to the frame homes on Wheeler Street. The deluge gun on Good Intent's 1958 Oren is in service. West End's aerial ladder, with ladder pipe ready, is in the upper left. The fire loss totaled $26,924.

A rescue is made over Phoenix's aerial ladder at the YMCA on July 28, 1965. A fire of suspicious nature, originating in the third-floor hallway, caused $13,000 in damage. Both Phoenix and West End used aerial ladders to rescue several men from the fourth and fifth floors of the large building, located at the corner of Second and West Market Streets. Box 14 sounded at 3:04 a.m. (Historical Society of Schuylkill County.)

Engineer Walter Byrnes stretches the booster line off Good Intent's Oren pumper as firefighters assist an injured civilian down the fire escapes on the Second Street side of the YMCA, at the corner of West Market Street, on July 28, 1965.

In celebration of the 100th anniversary of the Phoenix Fire Engine Company No. 2, members pose with the apparatus in front of the firehouse, at 320 East Norwegian Street. Originally organized as the Schuylkill Hydraulians in 1830, the company was reorganized in 1867 as the Phoenix Fire Engine Company No. 2. (Phoenix Fire Engine Company No. 2.)

Fire begins to vent from the second-floor apartment above Blum and Fennel Antiques, at 523 South Centre Street. Booster lines are stretched into the building as Fire Chief Andrew Hoke directs the troops, evidently asking the firefighter from Good Will to give the fire a shot from the street with his booster line. Box 25 sounded at 6:40 p.m.

The firefighter from Good Will shown in the previous photograph uses his booster line to hit the fire on the second floor of the occupied multiple dwelling. Note the preponderance of the Mine Safety Appliances (MSA) all-purpose filter-type masks being worn. The cause of the fire was unknown, but $7,945 worth of damage resulted. (Historical Society of Schuylkill County.)

Firefighters run ladders up and press the attack at the 523 South Centre Street fire. In the background, they can be seen donning protective equipment on top of American Hose's pumper. Good Will's distinctive white GMC-American pumper is also visible.

Good Intent's Oren pumper and Phoenix's ladder are in the foreground as firefighters access the roof at this fire on December 26, 1968. Box 63 sounded at 3:30 p.m. for the home at 241 Wallace Street. The fire, caused by an overheated furnace, resulted in $946 in damages.

After having completed the fire department photograph in 1965, Bill Glosser, Joe Neary, and Bill Stock pose in front of Good Intent's 1937 Oren 500-gallon-per-minute pumper. The tiller of Phoenix's aerial ladder can be seen in the background.

Booster lines over ladders are the order of the day as firefighters work to contain the fire at 2147 West Market Street, caused by a defective chimney. Damage was estimated at $2,500.

The Mars warning light and door emblem on Yorkville's 1949 Maxim Quad are clearly seen as it goes into service at 2147 West Market Street on March 18, 1963. The sounding of Box 78 immediately followed a still alarm at 3:15 p.m.

The pride of Pottsville is on display as apparatus from all eight city fire companies appears in this 1965 photograph.

Ice-encrusted Dennis McCabe mans the deluge gun atop Good Intent's 1958 Oren pumper at the Pottsville Showcase fire, on January 19, 1971. The courthouse clock reads 8:05 a.m., but Box 43 sounded at 2:50 a.m.

Phoenix's open-cab American LaFrance is covered with ice after having battled the Pottsville Showcase fire, at Third and West Race Streets, on January 19, 1971. Note the portion of the windshield cleared so the driver has a little forward visibility. Box 43 sounded at 2:50 a.m. Phoenix finally returned to quarters at noon that day. (Phoenix Fire Engine Company No. 2.)

Five

TRIAL BY FIRE
1970–1979

Several large conflagrations seriously challenged the Pottsville Fire Department during the 1970s. The department responded to this challenge with additional equipment upgrades and greater training opportunities. A new fire chief was selected in 1975. Pottsville firefighter Todd March of Yorkville Hose & Fire Company replaced Andrew Hoke, a member of Greenwood Hill Fire Company. Hoke had served as fire chief since 1958. The Good Intent Fire Company decided to replace its 1958 Oren with a new 1,000-gallon-per-minute custom pumper from the Hahn Motors, a fire truck builder in nearby Hamburg. The new Hahn was delivered in 1975 at a cost of more than $56,000. Also in 1975, the American Hose Company remained loyal to its American LaFrance heritage by purchasing a new Custom Century 1,000-gallon-per-minute pumper. The 1952 American LaFrance pumper was sold to the nearby East End Fire Company of Palo Alto.

With increased rescue calls due to vehicular accidents, Yorkville Hose & Fire Company purchased a Hurst rescue system in the mid-1970s, outfitting its rescue equipment on its 1967 Maxim Quad truck. This truck saw considerable action all over Schuylkill County during the 1970s as the volume of rescue calls increased and the number of county fire companies offering rescue service was limited. A major refurbishment and certification of the Phoenix Fire Engine Company's American LaFrance ladder truck occurred in 1978. The truck received a new Detroit diesel engine with an Allison automatic transmission. For the safety of its members, the cab and tiller were enclosed for the first time. The 1970s witnessed the increased usage of diesel power and automatic transmissions within the department.

The Humane Fire Company had good reason to celebrate in the early 1970s. In 1973, the Humane made the final mortgage payment on its new fire station to the Union Bank and Trust Company. In a fire company ceremony, Humane officers burned the mortgage for its new fire station, having paid off all debts in only four years. In 1978, Humane company officials ordered a new Seagrave WB model 1,250-gallon-per-minute pumper. The pumper was delivered in 1980. Another tragic firefighter fatality occurred in 1978. Ralph Downing, a member of the Humane Fire Company, died from injuries received while directing traffic at Route 61 and Mount Carbon. Downing became Pottsville's fifth line-of-duty death.

The 1970s also witnessed improved training opportunities. Several hundred Pottsville firefighters participated in the annual Schuylkill County Fire School Weekend, conducted every September at Lakewood Park during this era. The Pottsville Fire Department provided instructors and equipment to this annual event. Additionally, the Pennsylvania State Fire Academy offered more local level training courses directly in local fire stations. The Pottsville Firemen's Relief Association had long provided insurance and benefits for injuries and deaths as a result of firefighting duties. Insurance benefits were now extended to training activities as well.

Phoenix begins operations with its ladder pipe at the height of the Pottsville Showcase & Equipment Company fire. The business was noted for supplying restaurants and taverns with necessary cooking equipment and furnishings. Good Will's white 1964 GMC-American 750-gallon-per-minute pumper is also in the photograph, taken from the 300 block of West Race Street. (Phoenix Fire Engine Company No. 2.)

The Pottsville Showcase fire brought Phoenix in service with its ladder pipe. Note the utility wires that had to be negotiated for the aerial ladder to be positioned. Ice can already be seen on the firefighters' turnout coats as well as the apparatus. (Phoenix Fire Engine Company No. 2.)

This view shows the conditions on the north side of the Pottsville Showcase fire. A firefighter atop West End's aerial ladder adjusts the stream pattern of the Black Widow fog nozzle at the tip of the ladder pipe. The building itself was quite imposing. Greenwood Hill's 1967 IH-Hahn 750-gallon-per-minute pumper is visible in the lower left of the photograph, which was taken near the front of the Humane Fire Company.

Everything was freezing. Heavy smoke is evident at the southeast corner of the Pottsville Showcase. In addition to the ice on the utility lines, hose lines lie frozen in the street.

Inside the Humane Fire Company, firefighter Jack Flannery of the Good Intent Fire Company looks like a Popsicle. Members of the Humane Ladies Auxiliary used hair dryers to thaw the ice on the turnout coat closures. The Humane is located less than a block from where the Pottsville Showcase & Equipment Company stood.

Heavy smoke continues to pour from the rear of the Pottsville Showcase. This view was taken from Humane Alley just north of the fire. From left to right are Humane's 1964 Seagrave 250-gallon-per-minute pumper, West End's Quint, and Greenwood Hill's IH-Hahn pumper. Note the heavy fire conditions evident on the first floor.

Another cockloft fire occurred in a row of frame houses at 525–527–529–531–533 Harrison Street. The aerial ladders—West End on the left, Phoenix on the right—again had to be carefully navigated through a tangle of overhead utility wires. The cause of the fire was unknown. Box 541 sounded at 7:10 a.m. on November 6, 1972. Fire damage to the five homes totaled $24,619. (Historical Society of Schuylkill County.)

The homes at 525–527 Harrison Street are again involved in fire on February 26, 1976. This was part of the same group of homes damaged on November 6, 1972. This time, however, the homes were vacant. The cause was not determined. Box 541 sounded again for the 1976 fire at 10:20 p.m.

Not even firehouses are immune. Charles Schuster, Jerry Brennan, and Joe Brahler survey the damage to Good Intent's basement social quarters following a devastating fire on November 15, 1972. Box 14 sounded at 1:11 a.m. for the firehouse at 7 North Second Street. Damage of $19,000 was done. The company's fire log was laid open, as it typically was in the first-floor engine room. The page to which it was opened carries a heavy brown staining as a lasting reminder of the fire. (Historical Society of Schuylkill County.)

In this true team effort, firefighters wearing various company designations on their turnout coats work together to bring this fire at 403–405 Peacock Street under control. Crews are operating on the rear roof of No. 403. Box 62 sounded at 5:15 a.m. on March 8, 1970.

Good Intent firefighters wearing Scott breathing apparatus prepare to enter the second floor of 403 Peacock Street. The foreman of the Humane (beneath the ladder) wears an all-purpose filter-type mask. The fire resulted in $9,600 damage to the wood-frame duplex.

Box 41 sounded at 2:58 p.m. on March 30, 1970, for a fire that damaged the attic of this home, at 1250 West Arch Street. West End had its smoke ejector in service in the attic window and a booster line stretched over the ground ladder. This block was hit hard by a fire four years later when five vacant homes were heavily damaged on March 31, 1974.

While always devastating, fires seem to be especially so around the holidays. This fire occurred on December 28, 1973, at 419–421–423 North Ninth Street. Box 511 sounded at 8:18 p.m. Firefighters are operating on the roof and attic area of the row of frame houses. The fire loss totaled $6,400. The cause was determined to be electrical in nature. (Historical Society of Schuylkill County.)

Firefighters have run portable ladders up and stretched hose lines at 1632 West Norwegian Street on March 5, 1971. The fire, for which Box 71 sounded at 9:22 p.m., caused $26,000 in damage. It is believed to have originated as a grease fire in the kitchen.

West End Hose Company is in service at the Evans Warehouse and New Penn Paper Company, at Temple and Water Streets. Box 64 sounded at 9:13 p.m. on January 20, 1973. Loss to the businesses was $99,178.99. Companies returned on January 21 at 12:00 p.m. and again at 6:06 p.m. for rekindles. (Historical Society of Schuylkill County.)

Several booster lines—two of which are off Good Will's pumper—are put in service to knock down this garage fire. The garage was located at the rear of 430 Harrison Street. Box 52 sounded at 9:17 a.m. on June 16, 1972. (Historical Society of Schuylkill County.)

Heavy fire venting from the rear of 452–454–456 Adams Street greeted arriving firefighters on March 7, 1974. Numerous hose streams are being directed into the rear of the homes. The three homes on Adams Street were destroyed, and another at 15 South Jackson Street sustained damage from radiant heat. The cause was not determined. The fire loss totaled $39,750. (Historical Society of Schuylkill County.)

In the early 1970s, lime yellow was touted as being the preferred color for fire apparatus, as it was said to offer higher visibility than the traditional red. The lime yellow rage reaches Pottsville as Fire Chief Andrew Hoke accepts the keys to his new lime yellow chief's wagon on March 26, 1974. (Historical Society of Schuylkill County.)

The lime yellow wave continued in Pottsville with Good Intent's purchase of a 1975 Hahn 1,000-gallon-per-minute pumper. The engine replaced the company's 1958 Oren 750-gallon-per-minute pumper. The rig, which was built in Hamburg, was placed in service on September 23, 1975. This Hahn engine is still in service with the Locust Gap Fire Company, near Mount Carmel. (Historical Society of Schuylkill County.)

Heavy smoke is evident as firefighters battle this Easter morning fire that occurred next door to Pottsville City Hall. Box 51 sounded at 10:15 a.m. on April 18, 1976, for 413–415 North Centre Street. The buildings, owned by the Pottsville Redevelopment Authority, were vacant. The rear tiller portion of Phoenix's aerial ladder truck is visible at the right. (Phoenix Fire Engine Company No. 2.)

The vacant buildings next to Pottsville City Hall are engulfed in flames. Firefighters from Yorkville prepare to go in service to the rear of 413–415 North Centre Street on Easter morning, April 18, 1976.

Good Intent's 1975 Hahn 1,000-gallon-per-minute pumper and West End's 65-foot Seagrave Quint operate next to each other in the front of the buildings at 413–415 North Centre Street on April 18, 1976. West End has the line charged to the ladder pipe. In the background behind the Phoenix aerial ladder is Pottsville City Hall. (Phoenix Fire Engine Company No. 2.)

The debris falling from above is the result of overhauling taking place at a fire that gutted an apartment above the Sauers Hardware Store, at 1942 West Market Street, on July 14, 1975. Box 722 sounded at 5:48 p.m. for the fire, which caused $43,000 damage. The Curios Goods antiques store occupies the building today.

Firefighter Dennis McCabe of the Good Intent Fire Company knocks down fire venting from the rear of this row of frame houses. The sounding of Box 57 brought firefighters to 705–707–709 North Second Street at 11:19 a.m. on December 18, 1975.

Firefighting father and son team Jerry Brennan and Kevin Brennan of the Good Intent run a roof ladder up to bridge the steep yard to the porch roof at the rear of 705–707–709 North Second Street. The cause of the fire was not determined.

Jerry Brennan takes the nozzle, and Dennis McCabe provides backup as the attack is pressed into the homes on North Second Street. Fire caused $4,200 to the two occupied homes involved. The third home was vacant.

Heavy smoke pushes from the upper floors of this duplex at 310–312 Fairview Street as firefighters advance hose lines into the homes. An electrical short caused the fire, which gutted the homes. Box 551 sounded at 8:46 a.m. on March 9, 1978.

Firefighters in the rear work to prevent fire originating in 310–312 Fairview Street from extending to 400 Fairview Street. Loss to 310–312 Fairview Street was $85,000. Damage to 400 Fairview Street, across a very narrow alley, was $5,000. Companies were in service about four hours.

98

A firefighter equipped with self-contained breathing apparatus is helped into the vacant warehouse at 14th Street and Laurel Boulevard on May 21, 1978. Box 41 sounded at 8:15 p.m. for rubbish burning inside the building. Companies were in service for about one hour.

An accident in the 800 block of West Market Street involving a fuel oil delivery truck, three cars, and a private home resulted in Box 42 sounding at 12:15 p.m. on June 13, 1977. Fire Chief Todd March confers with Assistant Chief Robert Dusel and another official at the scene. (Historical Society of Schuylkill County.)

A row of frame houses was again involved in Pottsville's Fifth Ward on April 29, 1975. Heavy exterior fire involving 401–403 Fairview Street damaged 307 Fairview Street as well as the Chevrolet Impala pictured here. Box 52 sounded at 2:24 a.m. for the fire, which was of suspicious origin. Fire loss totaled $6,400, with no loss recorded for 401 Fairview, which was vacant. (Historical Society of Schuylkill County.)

The Peacock Street Housing Project was relatively new when fire struck on January 2, 1974. Box 68 sounded at 6:10 p.m. Units 15, 16, 17, 18, and 19 were involved. The cause of the fire was unknown. Damage was $72,500. This same stretch of homes was struck by fire again on February 3, 1981, when a propane leak caused a fire, resulting in $5,300 worth of damage. (Historical Society of Schuylkill County.)

One of the most tragic addresses in Pottsville history is 109 South George Street. At 1:51 a.m. on February 26, 1975, fire struck 105–107–109 South George Street. A male victim was found deceased in the third-floor bedroom of No. 109. In a previous fire, at 9:40 p.m. on July 17, 1965, a baby girl died in the third-floor bedroom of 109 South George. The cause of the 1975 fire was an overheated stovepipe. The cause of the 1965 fire was a candle. (Historical Society of Schuylkill County.)

Fire Chief Todd March directs operations from atop West End's ladder truck as crews battle a July 18, 1976, fire that heavily damaged the Dairy Queen restaurant, at Route 61 and Mill Creek Avenue. Box 67 sounded at 6:52 a.m. An electrical short circuit caused the fire, which resulted in $85,000 in damage.

Phoenix also has its stick to the roof as crews work to ventilate the Dairy Queen restaurant. This photograph was taken on the Mill Creek Avenue side of the building. Note the firefighter with the cut-off saw near the peak of the roof on the Route 61 side. Rite Aid pharmacy stands on this site today. (Historical Society of Schuylkill County and Phoenix Fire Engine Company No. 2.)

The rear of 1101 West Arch Street is well involved as companies arrive on scene of this June 17, 1977, fire at 1101–1103–1105–1107 West Arch Street. This stretch of homes was and still is owned by the Pottsville Housing Authority. The fire was caused by a pot of cooking oil on the stove. Box 41 sounded at 4:05 p.m.

On a cold night, firefighters battle this fire at the Seider's Printing Company, at 110 East Arch Street. Box 14 and Box 17 sounded at 8:03 p.m. on January 23, 1979. This arson fire caused $98,500 damage to the business.

Heavy smoke billows from the Pottsville Club at the height of the fire that destroyed the historic building, at 314 Mahantongo Street. A firefighter equipped with a breathing apparatus operates on West End's aerial ladder in front of the building. Box 36 sounded at 5:00 a.m. on October 15, 1974.

This view shows the Pottsville Club fire at daybreak. From front to back, Good Intent, Good Will, and West End operate on Mahantongo Street. The color and volume of smoke indicate that heavy fire conditions still exist in the upper floors and roof of the building. Damage totaled $325,000. The fire was deemed suspicious.

The Memorial Day parade on May 28, 1979, was a good opportunity for the Pottsville Fire Department to display its new uniforms. Up to this time, each of the eight individual companies had unique uniform styles and colors. A standard design for the Pottsville Bureau of Fire was adopted and continues basically unchanged to this day.

A firefighter from the Humane "heels" the ladder as booster lines are stretched to the second floor of this house, at 319 Laurel Boulevard. A child playing with matches caused this fire on November 28, 1978. Box 522 sounded at 11:40 a.m. Damage was $7,500.

At the twilight of his 17-year career as fire chief of the city of Pottsville, Andrew Hoke tests Box 114, at Second and West Norwegian Streets. Hoke, who replaced Fire Chief George Smith in 1958, retired in December 1975. The city fire bureau's current chief, Todd March, took over at that time.

Six
THE MODERN ERA
1980–PRESENT

Counter to the nationwide trend of consolidation and downsizing, the Pottsville Fire Department entered the modern era with all eight fire companies still serving the city. The fierce independence of the fire companies and their proud, glorious history rendered consolidation difficult. Meanwhile, the population of Pottsville has dwindled to less than 16,000. While recruitment problems and manpower shortages have sporadically occurred, the eight fire companies making up the Pottsville Fire Department continue to serve the city well. The modern era also saw increased training standards, with an 88-hour Essentials of Firefighting state training course a prerequisite for interior firefighting duties. With decreased manpower, most Pottsville fire companies broke a long tradition and invited female firefighters to join their ranks during this time.

Several interesting equipment and apparatus purchases occurred in the 1980s. With its volume of rescue calls ever increasing, the Yorkville Hose & Fire Company bought a 1981 International-Swab heavy rescue truck. This well-equipped truck served the county and city well and received a first-place award at the 1981 Pennsylvania State Firemen's Convention. A new Pottsville firefighting tradition commenced in the 1980s. The Pottsville Fire Department hosted the 1984 Schuylkill County Firefighters' Association Convention, and, due to the success of the event, decided to host the convention every 10 years. In October 1984, the American Hose Company received a new American LaFrance 1,500-gallon-per-minute pumper. This fire engine came equipped with an on-board foam system and large-diameter hose, two technological advances at this time.

The Good Intent also ordered a new 1988 Hahn 1,000-gallon-per-minute custom pumper, the first modern-era truck to feature a four-door cab.

The Pottsville Fire Department continued it modernization into the 1990s. The Phoenix Fire Engine Company's venerable 1959 American LaFrance aerial was refurbished again in 1992. Hydraulic outriggers, more compartments, and a cab extension were included in this project. Greenwood Hill Fire Company upgraded to a 1991 Hush 1,500-gallon-per-minute pumper, replacing both the 1966 Hahn and the 1947 International-Darley pumpers. The West End Hose Company made a major apparatus investment in 1992, with a new 1992 E-One Hush 75-foot aerial quint with a 1,500-gallon-per-minute pump. This marked the first apparatus purchase by the West End since 1977. The Good Will Fire Company returned to a single-engine company, with the purchase of a 1993 Spartan-Quality 1,500-gallon-per-minute custom pumper. Yorkville Hose & Fire Company made apparatus purchases in the 1990s: a 1992 Spartan-Swab heavy rescue truck and a 1997 Spartan-Swab 2,000-gallon-per-minute custom pumper.

The trend for larger pump sizes continued in this era. The American Hose Company bought a 1996 E-One 2,000-gallon-per-minute custom pumper, while the neighboring Good Intent Fire Company purchased a 1998 E-One Cyclone II 1,250-gallon-per-minute custom pumper. The Humane Fire Company obtained a 1999 Seagrave 2,250-gallon-per-minute custom pumper, making the final apparatus purchase of the 20th century. Three Pottsville fire companies are currently awaiting arrival of new fire apparatus for the 21st century.

Firefighters from the Good Intent and Phoenix prepare to remove a male victim rescued from the second-floor window of 431 East Market Street on January 17, 1982. Box 16 sounded at 6:29 p.m. for the fire, which was caused by careless smoking. The fire loss totaled $54,500.

Operating in the rear of 431 East Market Street on a cold January 17, 1982, proved to be a challenging task. As firefighters advance hose lines over ladders, water turns to slush and ice all around them. Crews from Good Will and Greenwood Hill fire companies are shown.

Firefighters desperately tried to rescue a 14-month-old boy from this home, at 567 East Arch Street, on January 25, 1980. Sadly, the child perished in the fire, which was caused by an electrical short in a heater cord. Box 16 sounded at 12:03 a.m. for the fire that caused $6,000 in damage. Firefighters are shown working in the rear of the building.

Phoenix has the stick to the roof at the vacant Leavitt's Furniture Store, at 510 North Centre Street, on August 7, 1980, as smoke pushes from the first-floor main entrance. An arson fire caused $32,000 worth of damage. Box 644 sounded at 7:27 p.m. This building was a repeat customer for the fire department, having been the scene of serious fires on January 26, 1933, and June 2, 1973. (Phoenix Fire Engine Company No. 2.)

On May 17, 1982, the sounding of Box 76 summoned firefighters to 2070–2072 West Market Street for a fire that was caused by spontaneous combustion. Heavy fire conditions are evident in the top floor as firefighters prepare to vent the roof. The alarm was sounded at 1:55 p.m. Fire loss to both homes totaled $45,970.

Hose lines are advanced into the Nativity Blessed Virgin Mary High School on May 2, 1980. An electrical short in wall light wiring caused the fire that heavily damaged the auditorium. Box 144 sounded at 3:15 a.m. Damage to the school totaled $308,705.

Firefighters stretch hose lines into this vacant home, at 506 Schuylkill Avenue, on July 12, 1981. West End positions its aerial ladder in the front of the building while navigating the overhead utility wires. Box 32 sounded at 2:25 p.m. for the arson fire, which caused $12,600 in damage.

The Good Will Fire Company No. 4 utilized two GMC-American pumpers for many years. They were virtually identical. A good fire buff, however, would quickly spot the differences in the fire bodies between the 1963 750-gallon-per-minute pumper on the left and the 1965 500-gallon-per-minute pumper on the right. Both featured high-pressure pumps. (Schuylkill County Historical Society.)

Humane's 1980 Seagrave model WB low-profile pumper is parked in front of the company's quarters, at Third Street and Laurel Boulevard. The engine, which is still in service with the Humane, carries a 1,250-gallon-per-minute pump and a 500-gallon water tank. The rig cost $86,000 when purchased. (Historical Society of Schuylkill County.)

Although the Yorkville Hose & Fire Company No. 1 had been providing specialized rescue services with its venerable Maxim rigs for many years, this was its first dedicated rescue truck. The International-Swab cost $100,000. After 10 years of hard service, it was replaced in 1992 by another Swab rescue truck. (Historical Society of Schuylkill County.)

This vacant factory, at 1610 West Norwegian Street, is in flames as companies arrive at the scene. Note the three-inch supply line laid in the street. Box 323 sounded at 11:06 a.m. on November 17, 1983. Fire seriously threatened the private homes on the right, but firefighters were able to contain the blaze to the building of origin.

Ladder pipes are prepared as fire burns through the roof of Dick's Tire Service on June 8, 1982. The early-morning fire gutted the building. Box 19 sounded at 1:00 a.m.

Heavy fire consumes the roof of Dick's Tire Service as firefighters put hose lines in service through the large service doors. The building was located on Claude A. Lord Boulevard (Route 61) just north of Union Street. The fire caused $78,000 in damage.

The use of Phoenix's aerial ladder is severely restricted by the overhead utility wires. Fire breaks through from the attic area of these frame homes at 804–806 Mount Hope Avenue. The homes were exposed by fire originating in Webb's Tire Service, at 800–802 Mount Hope Avenue. The fire occurred on March 27, 1982.

West End has the ladder pipe prepared on its 1977 Seagrave 100-foot quint as the homes next to Webb's Tire Service become heavily involved in fire. Box 523 sounded at 5:27 a.m. for the fire, which was determined to be arson.

Assistant Fire Chief Bill Horning works on Phoenix's aerial ladder to expose fire consuming the roof of 2064 Mahantongo Street. The fire occurred at a mental health group home. One resident was rescued by firefighters, but another was tragically killed in the fire, which was caused by careless smoking. Box 73 sounded at 9:00 p.m. for the fire, which resulted in $63,000 in damage.

116

This tragic fire occurred on March 5, 1984, a snowy day. A heavy column of smoke rises into the sky as fire devastates the frame duplex at 512–514 Hotel Street. A mother and her five-year-old son were killed in the fire. The sounding of Box 25 summoned firefighters to the scene at 8:56 a.m. Downed power lines hampered the approach of fire apparatus.

With several hand lines, firefighters press the attack into the homes at 512–514 Hotel Street. American Hose's 1975 American LaFrance 1,000-gallon-per-minute pumper can be seen stopped short of the power lines that had dropped across the street as a result of the heavy fire in the front of the homes.

Firefighters from the Good Intent stretch hand lines over a ground ladder in the rear of 202 North Second Street. Children playing with matches caused the fire that damaged a second-floor apartment. Box 115 sounded at 9:03 a.m. on January 19, 1985. This was the first of several serious fires to strike Pottsville in the first several months of 1985.

Firefighters from the Phoenix are in service at 467 Peacock Street on February 8, 1986. Box 62 sounded at 5:44 p.m. for the fire, which damaged the second floor of the home. Co-author Mike Glore transmitted the alarm for this fire after spotting smoke coming from the eaves of the home while traveling on Peacock Street.

Fire engulfs 39 Peacock Street on July 19, 1984, as residents move to safety. Box 68 sounded at 10:46 a.m. for the fire in the Pottsville Housing Authority complex. The fire erupted when gasoline vapors in the first floor of the home ignited. The 70-year-old resident of the home died on July 25, 1984, from burns sustained in the fire.

Seagrave apparatus from the Humane and West End go nose-to-nose at 500 North 18th Street on August 28, 1985. A pot of grease on the stove gutted this single-family home. Box 713 sounded at 2:45 a.m. for the fire, which caused $87,500 in damage. Assistant Fire Chief Jack Messner gets the troops in order in the center of the photograph.

119

One of the largest and most challenging commercial fires to strike Pottsville occurred on January 18, 1984, at the Reiland Potato Chip Company, at Ninth Street and Laurel Boulevard. Fire is through the roof as both Phoenix and West End have the ladder pipes in service. The fire caused $665,000 in damage. Box 511 sounded at 5:50 p.m.

Fire engulfs the rear of the Reiland Potato Chip Company on January 18, 1984. Firefighters were successful in keeping the fire from entering the former warehouse of Pomeroy's department store. This huge wooden building was located only a few feet east of Reiland's. The fire occurred during a snowfall, as evidenced in the photograph.

On March 10, 1985, Box 513 sounded at 2:37 a.m. for a fire involving six homes on Morgan Avenue. Firefighters attempt to vent the roof of the duplex in which the fire originated. The fire spread through the common attic space in the four homes on the right. In all, three homes were gutted and three others sustained fire damage.

This view shows the conditions at the rear of the Morgan Avenue fire. Heavy smoke signals that the fire is spreading rapidly through the wood-frame row houses. The fire caused $295,280 damage to 429–439 Morgan Avenue. The cause was determined to be careless smoking.

March 16, 1993, was a tragic day in Pottsville, as two young boys perished in their burning home at 417 Pierce Street in the city's Bunker Hill neighborhood. Box 34 sounded at 3:37 p.m. for the fire, which also destroyed 415 and 419 Pierce Street. Co-author Mike Glore of the Good Intent and Dale Blum of the Humane attempt to rescue the boys, who were last seen at a top-floor window of the home. They were forced to retreat when the window below them failed and flames engulfed the ladder. The fire occurred shortly after the Blizzard of '93, which complicated firefighting efforts on the very narrow, hilly streets. (Mike Orazzi photograph, *Pottsville Republican*.)

Firefighter Rusty Dalton prepares to put Phoenix's aerial ladder in service at the fire on Pierce Street. Phoenix's efforts were hampered for a time when overhead power lines failed and draped across its ladder truck. The home in which the fire originated was consumed very quickly, and fire spread rapidly to the homes on either side. The damaged 35-foot ground ladder that was used in the rescue attempt can still be seen placed against the building.

One of the largest commercial fires to hit the city since the Reiland Potato Chip fire in 1984 occurred on April 21, 1995, when the Davis Building, on Route 61 near the intersection with Mill Creek Avenue, was destroyed. West End prepares to hit the fire with the elevated master stream on its 1992 E-One 75-foot quint. Box 67 sounded at 11:41 p.m.

Fire is showing from the front of several row houses on a very narrow North Ninth Street. Box 45 sounded at 8:43 a.m. on May 7, 1993, for the fire, which destroyed 298–308 North Ninth Street. Palo Alto, Minersville, Schuylkill Haven, and Port Carbon provided mutual aid. This was the most serious row house fire in Pottsville in many years.

Taken in 1994, this photograph offers a unique historical perspective, as one can compare fire apparatus from the different eras. From West End's 1928 Ahrens-Fox to Good Will's 1993 Spartan-Quality pumper, the progression of fire apparatus technology is evident. With additional new apparatus having arrived and with some expected in the near future, the Pottsville Fire Department enters the 21st century with a proud past and a promising future, as well as a well-trained and well-equipped emergency service organization.

Shown is a recent fire at a very old building. Phoenix prepares the ladder pipe at this fire, which destroyed the Pick-A-Pack beverage store, at 430 South Centre Street, on March 20, 2001. Box 25 sounded at 10:11 a.m. This building once served as the state police barracks in Pottsville and was a very prominent fixture on South Centre Street.